IMAGES
of America

RANCHO SANTA FE

MISSION. The Ranch Santa Fe Historical Society's mission statement is "to collect, preserve, research, and interpret the documents, photos and artifacts that connect us to Rancho Santa Fe and its past. The opportunity to learn more about the history of this special village is offered through exhibitions, historic sites, the archives, special events, educational programs and publications."

ON THE COVER: From the La Morada Inn, master architect Lilian J. Rice surveys the emerging landscape of Rancho Santa Fe around 1925. (Courtesy of the San Diego Historical Society.)

IMAGES
of America

RANCHO SANTA FE

Vonn Marie May
Rancho Santa Fe Historical Society

ARCADIA
PUBLISHING

Published by Arcadia Publishing
Charleston, South Carolina

Printed in the United States of America

Library of Congress Control Number: 2009925986

For all general information contact Arcadia Publishing at:
Telephone 843-853-2070
Fax 843-853-0044
E-mail sales@arcadiapublishing.com
For customer service and orders:
Toll-Free 1-888-313-2665

Visit us on the Internet at www.arcadiapublishing.com

This book is dedicated to the five women who founded the Rancho Santa Fe Historical Society in 1984: Pat Cologne, Eleanor Shefte, Sandy Somerville, Marcia Van Liew, and Gwen Whitehead. Without their collective commitment to the preservation of Rancho Santa Fe's history and the collection of artifacts, this book would not have been possible.

CONTENTS

ACKNOWLEDGMENTS

Special thanks in bringing the *Rancho Santa Fe* book together goes to editor Holly Manion for her personal knowledge of Rancho Santa Fe and her editing and research skills; Gijs Hanselaar for his computer graphic expertise with the Rancho Santa Fe Historical Society image collection; Tom Clotfelter for his poignant remembrances; and Robert Donald Macdonald, Fred Ashley Jr., and Rancho Santa Fe Historical Society administrator Sharon Fabry for their contributions.

All images used in this book came from, and are available at, the Rancho Santa Fe Historical Society unless otherwise noted. Extraordinary thanks goes to Col. Charles R. Nelson for his masterful documentation of the ranch. Thanks to the Clotfelter, Smart, and Boettiger families for their donations of images and to the work of professional photographers Herbert R. Fitch and Bunnell, long ago hired by the Santa Fe Railway to document their project. Gracious thanks goes to the Reitz family for their donation of the historic La Flecha House and its contents, home to the Rancho Santa Fe Historical Society.

The Rancho Santa Fe Historical Society will celebrate its 25th anniversary in 2009.

2008 Rancho Santa Fe Historical Society Board of Directors:
Chaco Clotfelter, president; John McCulley, vice president; John Vreeburg, treasurer; Sue Bartow, secretary; Vicki Acri; Gordy Bartow; Steve Cologne; David Herrington; Debi Holder; Gene Magre; and Vonn Marie May.

2009 Rancho Santa Fe Historical Society Board of Directors:
John Vreeburg, president; Chaco Clotfelter, vice president; Vicki Acri, treasurer; David Wiemers, secretary; Gordy Bartow; Peggy Brooks; Steve Cologne; Gijs Hanselaar; David Herrington; Debi Holder; Paul Johnson; Vonn Marie May; and Sharrie Woods.

INTRODUCTION

The community of Rancho Santa Fe reveals itself through layers of California history. History that moves from a Spanish pueblo, to a Mexican rancho, to an ambitious horticultural experiment gone awry, and finally to an inspired planned community. The very name, Rancho Santa Fe, is a result of the marriage of these historical eras testifying to life in southern California during the 19th and early 20th centuries. This extraordinary tract of land continues to convey its history even today.

Rancho Santa Fe began with the Atchison, Topeka and Santa Fe Railroad (ATSF), which exclusively served the Southwest in a time when railroads were connecting the East to the West Coast. Railroad planners realized they would need hundreds, if not thousands, of miles of wooden ties to underpin their rails. But by the turn of the century, America had already consumed many of its forests. Pres. Theodore Roosevelt, a strong conservationist, warned of a "hard wood" famine, especially in California.

The search was on for an alternative wood, one that would produce results quickly. The ATSF, through its subsidiary, the Santa Fe Railway, began a study of the fast-growing Australian genus, eucalyptus. As early as the 1850s, eucalyptus was seen throughout the California landscape, often used for windrows, shady lanes, and health remedies. Now they were to serve a larger purpose. Railroad ventures had exhausted Australian forests, causing the exportation of seed—and tons of it.

The Santa Fe Railway also sought out the perfect growing grounds, a place that would be large enough to yield millions of trees. North San Diego County was deemed to have the ideal components for an ambitious project, with the perfect soil and the perfect climate. In 1906, the Santa Fe Railway found Rancho San Dieguito, a languishing Mexican-era land grant, and purchased it from the heirs of the grantee, Don Juan Maria Osuna. Other speculative buyers and landowners had come and gone, but with the resources of the ATSF, the entire boundary of the original land grant was kept intact.

Juan Osuna was a significant player during the Spanish colonization of Alta California and later the Mexican Republic period. He rose to positions of prominence, serving as the *mayordomo* of the Mission D'Alcala and as the first alcalde (mayor) of San Diego during its Mexican Republic era.

Osuna was granted two (Spanish) leagues—8,824 acres of land—by the last Mexican governor of Rancho Santa Margarita, Don Pio Pico. He named it Rancho San Dieguito, or "little San Diego." The land he chose captured many of the characteristics of San Diego: hills, streams, agricultural lands, saltwater and freshwater wetlands, and vistas of surrounding mountains and the Pacific Ocean. Osuna and his wife, Juliana Josepha Lopez, and their eight children moved from what is now Old Town San Diego to Rancho San Dieguito in the 1840s. They built two adobe homes: Osuna 1, a remodel of a prior grantee Librado Silvas; and Osuna 2, a larger home closer to the San Dieguito River where Juan and Juliana lived. Osuna remained on the property until his death in 1847.

Families who owned ranchos prior to California statehood had to prove their right of ownership to the U.S. government. It wasn't until 1871, after two decades of legal wrangling, that the widow of Juan Osuna was awarded the entire land grant. After her death eight months later, the property went to the Osuna children. From that period on, the Osuna family lost most of their holdings, reducing the acreage from nearly 9,000 acres to less than 300.

After securing the land grant, the Santa Fe Railway immediately set out a rigorous planting program. The chosen species of eucalyptus were planted northwest of the San Dieguito River on 3,000 acres of the best soil and maximized at 10 feet apart. From 1906 to 1912, an instant forest emerged. But as the saying goes, "whatever can happen did." A series of near-catastrophic events, including drought, heavy rain, an uncharacteristic freeze, and the fact that eucalyptus was not effective until it reached "old growth" stage, the Santa Fe Railway found their bottom line: they could purchase Oregon Douglas fir cheaper. By 1916, the railroad's eucalyptus experiment came to a crashing end. What remains today is but a portion of the original 3.5 million eucalyptus trees planted. A century later, the fragrant and willowy eucalyptus groves are a significant part of the landscape and ambiance of Rancho Santa Fe.

After accepting defeat, the Santa Fe Railway considered putting Rancho San Dieguito up for sale. A local development entrepreneur, Col. Ed Fletcher, expressed interest in the land for future development. He approached the Santa Fe Railway with a possible solution, one that would also benefit his ongoing developments in Del Mar and Solana Beach. What resulted from this interim period was Fletcher managing the property for the railroad. He leased out the lands for ranching and annual crop farming and began preliminary road building. Fletcher piqued the interest of the railroad by suggesting another planting program that would grow oranges and other fruit-bearing trees by the thousands. He knew the Santa Fe Railway made more money off "tonnage," or freight, than passenger rail. As helpful and farsighted as Fletcher was, he also had his own development interests at heart.

Convincing the Santa Fe Railway to plan Rancho San Dieguito as an agricultural development would require a sizeable and predictable source of water, which would be a critical and very expensive enterprise that would need immense resources. Fletcher's connection with another local landowner, William Henshaw, provided the necessary path to that water supply. Henshaw owned the land upstream surrounding the San Dieguito River. The very influential Fletcher secured the land for a dam and lake site. By 1918, Hodges Lake and Dam, funded by and named for Walter E. Hodges, vice president of the Santa Fe Railway, became a reality. The dam delivered water to a reservoir on the ranch and a newly established Santa Fe Irrigation District.

The change of course from eucalyptus to predominantly citrus trees was fully launched. In 1921, the Santa Fe Land Improvement Company was formed and set about planning for residential and orchard use. They hired land expert Leone G. Sinnard to survey, engineer, and begin construction of the new project. The concept of the "gentleman's estate" or the "gentleman farmer" came to fruition. Sinnard's first impression of the property and the Santa Fe Land Improvement Company's sweeping goal was to comment, "The Santa Fe Land Improvement's first and primary goal should be an intensive, high-class horticultural development."

With a resolved intent, it was determined the land would be a sophisticated agricultural co-op that would ensure high-end dwellings and at the same time render to Santa Fe the citrus freight for transport. After completing his feasibility study entitled "Proposed Subdivision of Rancho San Dieguito," Sinnard filed the project in December of 1922 with the County of San Diego. The Santa Fe Railway retired the historic name of Rancho San Dieguito, replacing it with their namesake, Rancho Santa Fe, and a planned community was born.

Sinnard performed comprehensive soil tests to accommodate the many orchard layouts that were soon to come. A consummate engineer, he also laid out each parcel encircling a civic core and built a sinuous road system connecting them all. He deferred to the natural form and character of the land, leaving a light imprint on it. Automobile leisure driving was at its peak, albeit for people of means. By 1923, the State of California had registered its millionth car, and planning for the automobile became a significant part of the ranch's layout.

Sinnard roads were designed for safety, and discouraged speeders, while providing breathtaking vistas at every turn. His proudest accomplishment was that all his roads could be driven in high gear. He also incorporated historical routes that traversed the ranch: the old Osuna Valley River Road became Via de la Valle, El Camino Real in its historic alignment was retained as the western boundary of the ranch, and the road east to Del Dios and Escondido became Paseo Delicias, which passed through the village center.

As the chief project manager, he was also given hiring authority. He selected the top experts in their respective fields: agronomist A. R. Sprague; landscape architect Glenn Moore; and the architectural firm of Requa and Jackson, who introduced the future Rancho Santa Fe project architect, Lilian J. Rice.

The architecture of the new project was always intended to capitalize on Spanish and Mexican traditions, in part inspired by the Osuna adobes. The work of Requa and Jackson—which fashioned a central core in the Spanish Mission revival style—could be seen when one visited the small village of Ojai. Sinnard commissioned the firm and began planning for an architectural style that would be specific to the ranch. Richard Requa was the lead designer but hired Lilian J. Rice, a native San Diegan and Berkeley-trained architect, to consult on all aspects of the project. Requa is credited with collaborating with both Sinnard and Rice on the village core. He was prominent in the design of the Rancho Santa Fe's offices. From then on, it was Lilian Rice who designed and supervised construction of all ranch architecture.

Lilian J. Rice was the sole architectural influence and relished her experience as the project of a lifetime. It fell to her to plan and design for the Rancho Santa Fe project and others. Between 1922 and 1928, she completed several civic core structures, including a guesthouse, a commercial office block, a garage block, apartments and offices, an elementary school, and her famous row houses. As the ranch's supervising architect, she was the first choice of new landowners for residential design. From 1928 until her untimely death in 1938, Lilian designed 58 estate homes on the ranch as well as several homes in La Jolla and different parts of the county.

Lilian's distinct styling came through in each design, often in collaboration with the homeowners. Her personal style was based on her training and exposure to Spanish villages in her travels, sponsored by the ranch. She composed a tranquil serenity of California indoor-and-outdoor living unlike anything else seen in the area. Reminiscing about her time at Rancho Santa Fe bears a heartfelt testimony:

> With the thought early implanted in my mind that true beauty lies in simplicity rather than ornateness, I found real joy at Rancho Santa Fe. Every environment there calls for simplicity and beauty—the gorgeous natural landscapes, the gently broken topography, the nearby mountains. No one with a sense of fitness, it seems to me, could violate these natural factors by creating anything that lacked simplicity in line and form and color.

The Santa Fe's advertising was conducted from their Los Angeles offices and aimed for the wealthy and the privileged. The community was praised as "California's community masterpiece" and at the same time one that was "probably the most highly restricted area of its size in the world." Names of early buyers were used as cachet in the advertisements, including capitalists, corporate officials, and bankers. Images of America's most beloved movie couple, Douglas Fairbanks Sr. and Mary Pickford, were exploited as well. They owned and operated Rancho Zorro, a 3,000-acre ranch on the southeast side of the river, known as one of the largest privately owned citrus orchards in California.

By 1928, the Rancho Santa Fe sold 80 percent of its property. It was time for them to sunset their interests and let the ranch fledge on its own. However, they couldn't bear the thought of suspending restrictions, which could result in the dissolution of the ranch's character. As their first and only planned community in their name, they felt a need to ensure the longevity of their vision. Walter Hodges engaged noted town planner Charles Cheney to help create a restrictive document.

Cheney authored the covenant code for Rancho Santa Fe, one that borrowed from his Palos Verdes model and also retained expectations set by the Santa Fe Land Improvement Company. What resulted was the Rancho Santa Fe Protective Covenant of 1928, a document that birthed the Rancho Santa Fe Association and the Rancho Santa Fe Art Jury, a design review board.

Several decades later, the Rancho Santa Fe Protective Covenant continues to guide the ranch's semirural character while considering new projects that arise almost annually. Thanks to the foresight of early visionaries and placemakers, these projects are vetted through the prism of covenant restrictions. The Rancho Santa Fe Village remains much like that of the original, as Leone Sinnard and Lilian Rice envisioned it. The roads leading in and out of the ranch are the same widths and alignments designed by Sinnard, and Lilian's architecture continues to inspire. Over the years, the Rancho Santa Fe Protective Covenant has been challenged by inappropriate development. Yet the members of the Rancho Santa Fe Association vote to uphold the basic tenets found within their protective covenant.

By embracing its historical precedents, Rancho Santa Fe moves into the future with its fundamental character intact. The lifestyle and visual character that early planners created is in full maturity. There would be no Rancho Santa Fe had it not been for the eucalyptus. Rancho Santa Fe is truly the town the railroad built.

One

RANCHO SAN DIEGUITO AND THE OSUNA LEGACY

Included in its boundaries were luxuriant little valleys, ample lengths of mesa, and a bubbling river.

—Osuna Family Records, San Diego Historical Society

Rancho Santa Fe was born out of an Old World Mexican rancho. In the 1840s, the area was named Rancho San Dieguito (little San Diego) because it mirrored the natural features of that city. Rancho San Dieguito was home to the first alcalde (mayor) of San Diego, Don Juan Maria Osuna.

Osuna was born in 1785 and raised at El Presidio Reál de San Diego. His father was a corporal in the Soldados de Cuera (Leather Jacket Company), who escorted Father Serra into Alta California at the onset of the Spanish colonial period. Osuna worked his way up the military ranks and by 1834 ran for alcalde against a notable opponent, Don Pio Pico, and prevailed.

Osuna married Maria Juliana Josepha Lopez, and the couple had two daughters and six sons. Wanting a large tract of land to ranch and build a family home, Osuna chose land north of San Diego that would become Rancho San Dieguito. The last Mexican governor of California, Don Pio Pico, once Osuna's political rival, awarded him the final provisional grant totaling 8,824.71 acres (two leagues).

The Osunas built two adobe dwellings: Osuna 1 (a remodel of the former Silvas adobe) for son Leandro; and Osuna 2, a larger adobe for Juliana and himself close to the river. Juan Osuna lived out his days at Rancho San Dieguito until his death in 1847. These two historical structures and their settings still exist and are the cradle of history for Rancho Santa Fe.

In 1906, the Santa Fe Railway bought the last 200 acres of Osuna property, along with other properties, and respectfully kept the grant boundary of Rancho San Dieguito intact.

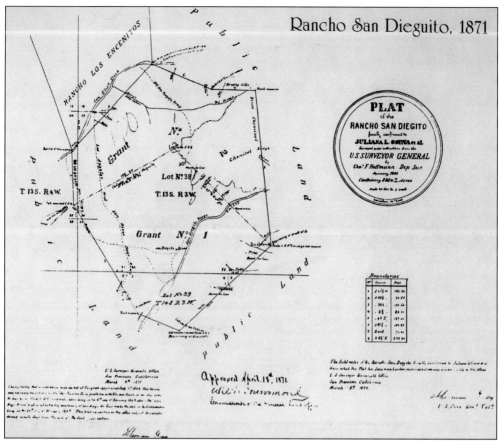

U.S. Government Map, 1871. Don Juan Maria Osuna received a provisional land grant in 1840, although records show he occupied the area by 1834. An additional grant was added by 1845, which brought Rancho San Dieguito to a total of 8,824 acres. In 1851, after California statehood, ranch owners were required to prove ownership of their land. It wasn't until 1871, twenty-one years after Osuna's death and eight months before Juliana's, that Rancho San Dieguito was finally patented to the Osuna heirs.

The Osuna Brand. From 1834 to 1846, Juan Osuna divided his time between San Diego, as alcalde and *mayordomo* of the San Diego Mission and Rancho San Dieguito. At Rancho San Dieguito, Osuna used his newly acquired land for cultivation and range for cattle and sheep. During the Mexican rancho era, cattle were the primary economy for the export of tallow and hide. Cattle roamed freely on the land but required identification.

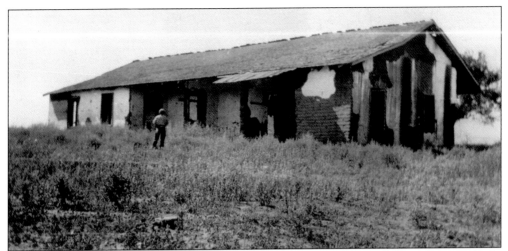

OSUNA 1 FRONT, DECADES OF NEGLECT. During the Osuna ownership, two adobes were built. Pictured here is Osuna 1, which was a remodel of the c. 1831 Librado Silvas adobe. It was situated near what is now Via de Santa Fe. It is believed that a living room and sleeping porch were added between 1865 and 1906. A second adobe was built, Osuna 2, on what is now known as Via de la Valle and became the home of Juan and Juliana Osuna.

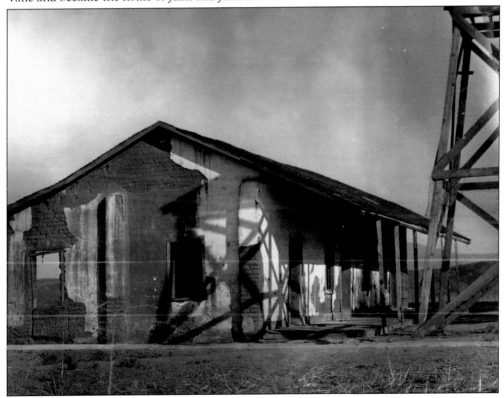

OSUNA 1 REAR, DECADES OF NEGLECT. When the Santa Fe Railway purchased Rancho San Dieguito, the condition of Osuna 1 was near-collapse, abandoned, and neglected for several decades. This photograph shows the original porch, which extended the entire rear elevation—ramada style—with a raised wood deck. A wood-framed water tower with a tank was the sole source of water.

13

OSUNA 1 FRONT, REHABILITATION PLAN. In 1923, Santa Fe architect Lilian J. Rice rendered plans for a rehabilitation of Osuna 1. Rice made minor changes to the floor plan. She added a new tile roof, improved structural integrity, applied new plaster inside and out, installed new windows and doors, created an indoor bathroom, and designed a sizable fireplace in the living room.

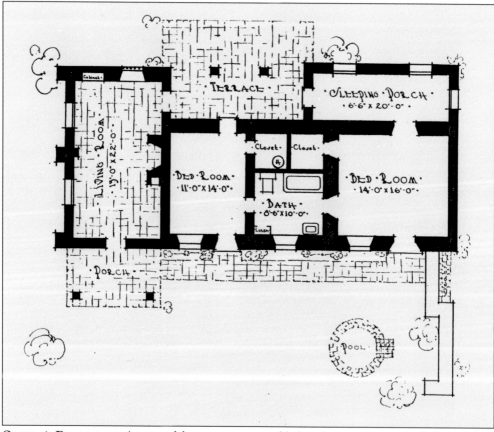

OSUNA 1, FLOOR PLAN. A covered front terrace was added to the main entry. A tiled porch roof and paved walkway were added along the rear elevation. A garden wall and a circular fountain adorned the back garden area. Sometime in the 1930s, the adobe was expanded to include a kitchen in the front terrace area.

Osuna 1 Rear, Rehabilitation Plan. The rear elevation plan shows a new tiled porch roof instead of the wood cover that once extended along the entire exterior facade. A garden wall added to the side of the house created an entry courtyard, which separated the garden from the road.

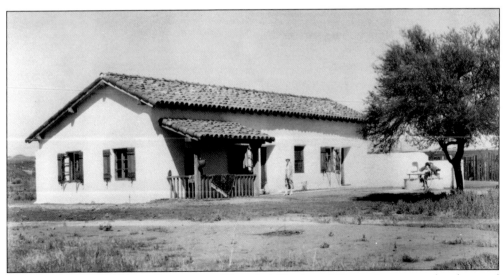

Osuna 1, Rehabilitation Completed. The rehabilitation of Osuna 1 was completed around 1924. It was paid for by prominent La Jolla real estate investor A. H. Barlow. Barlow is credited for having the foresight to bring this significant artifact from the Spanish-Mexican period back to life.

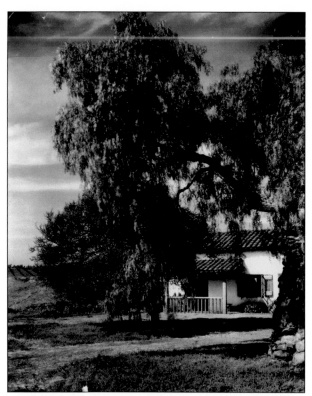

Osuna 1, c. 1928. A beautifully composed picture of Osuna 1 frames the adobe with its historical mission pepper trees. On the left in the distance, one can see rows of citrus trees in a young orchard. Rancho Santa Fe was beginning to realize its cultural character as it matured each year.

Osuna 1, Garden. The southwest corner of the rear elevation shows garden elements introduced by Lilian Rice. The fountain had a clay-tile water spigot and miniature clay-tile gabled roof. Some elements of this focal piece have been compromised. The site wall once had a pilaster at the end.

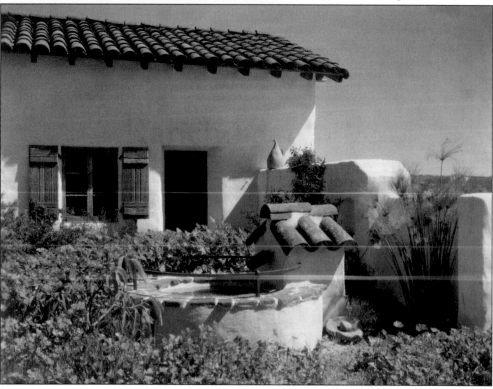

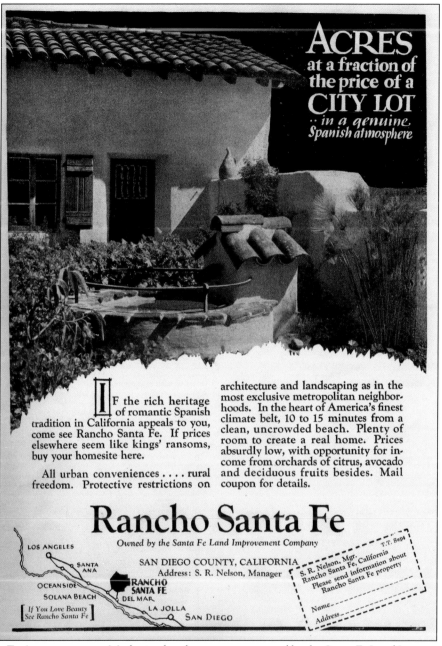

ACRES
at a fraction of the price of a
CITY LOT
·· in a genuine, Spanish atmosphere

IF the rich heritage of romantic Spanish tradition in California appeals to you, come see Rancho Santa Fe. If prices elsewhere seem like kings' ransoms, buy your homesite here.

All urban conveniences rural freedom. Protective restrictions on architecture and landscaping as in the most exclusive metropolitan neighborhoods. In the heart of America's finest climate belt, 10 to 15 minutes from a clean, uncrowded beach. Plenty of room to create a real home. Prices absurdly low, with opportunity for income from orchards of citrus, avocado and deciduous fruits besides. Mail coupon for details.

Rancho Santa Fe
Owned by the Santa Fe Land Improvement Company

LOS ANGELES

SANTA ANA

OCEANSIDE

SOLANA BEACH

RANCHO SANTA FE

DEL MAR

LA JOLLA

SAN DIEGO

SAN DIEGO COUNTY, CALIFORNIA
Address: S. R. Nelson, Manager

[If You Love Beauty
See Rancho Santa Fe]

T.T. Sept
S. R. Nelson, Mgr.
Rancho Santa Fe, California
Please send information about Rancho Santa Fe property

Name_____

Address_____

SANTA FE ADVERTISEMENT. Marketing brochures were generated by the Santa Fe Land Improvement Company exploiting the rich heritage of California's Spanish traditions. In this advertisement, the newly restored Osuna 1 is prominently featured to purposely evoke romantic imagery. Osuna 1 became the primary cultural influence for the architecture of Rancho Santa Fe. The Santa Fe Land Improvement Company's marketing offices were in downtown Los Angeles. Even though these advertisements were meant to appeal to potential investors on a quality-of-life basis, railway officials were clearly planning to profit from the "tonnage" of citrus to be moved back East. In 1925, the sales brochure clearly states their motivation, "Tonnage (agricultural product) for the railway—not profit from the sale of land—is the objective."

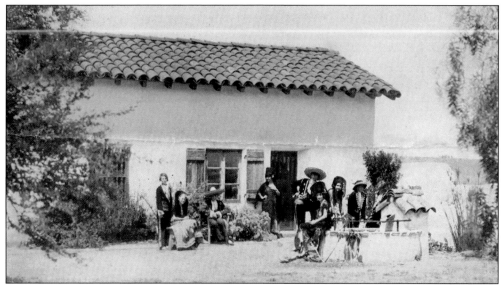

OSUNA 1, FIESTA DAYS. A rehearsal of the play *The Dreamer*, which depicted early life at Rancho San Dieguito, is shown here. The play was performed on June 17, 1927, by the pupils of the Aliso School under the direction of their teacher, Betty Thomas. The cast consisted of Bobby Nelson as the dreamer, Virginia Voris as Crissorita, Ruth Fidero as Don Juan Osuna, Jean Attrill as the Spirit Child, Martha Voris as Doña Juliana Osuna, and Kathryn Maddox as Leandro Osuna.

— "what they dreamed would come to be their ancestral home" —

OSUNA 1, EARLY DRAWING. This quote, taken from the "Endless Miracle" pamphlet in 1928, alludes to the sentiment toward the Osuna 1 adobe. Truly it was a cherished site reminiscent of the Rancho San Dieguito days and primary inspiration for the architecture of Rancho Santa Fe. Had not the Santa Fe Land Improvement Company been so enamored with this fragile adobe, Rancho Santa Fe would have taken on an entirely different character.

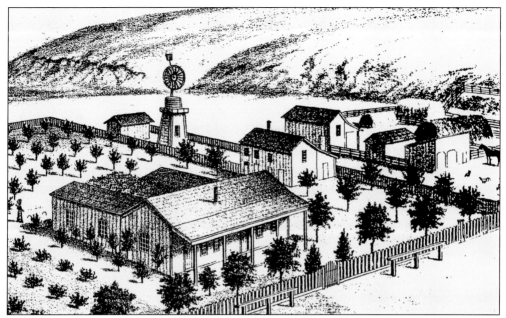

DRAWING OF OSUNA 2, 1888. This drawing was generated long after Juan and Juliana Osuna had passed. Yet it reflects the robust ranching and farming complex that it came to be. Juan Osuna's second house was in almost constant use and did not suffer any serious disrepair like Osuna 1. Juan Osuna described the adobe as "consisting of one sala and three rooms." It is apparent that much was added onto the property after the 1870s and through the 20th century.

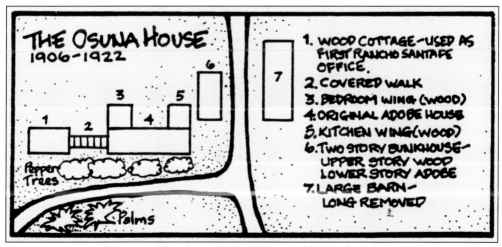

DIAGRAM OF THE OSUNA 2. This drawing was originated by Ruth Nelson to illustrate the use of the old Osuna 2 compound by the Santa Fe Land Improvement Company. The Santa Fe was based on this property for 16 years. All the planning and construction stages of the project were generated from these buildings.

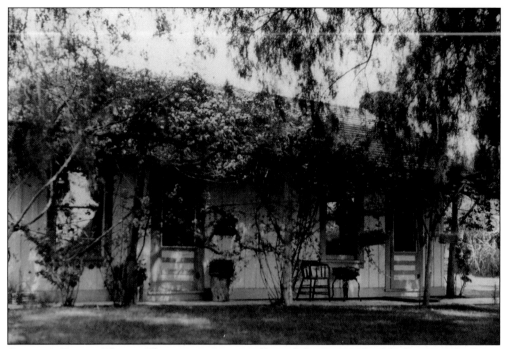

OSUNA 2, RANCH HOUSE. This unassuming, small ranch house was the first home to the Santa Fe Railway and later the Santa Fe Land Improvement Company office. It was from this rural setting that Rancho Santa Fe was born. The ambience of this period was not unlike that when the Osunas lived here. Today its privately owned and retains most of its historic character some century and half later.

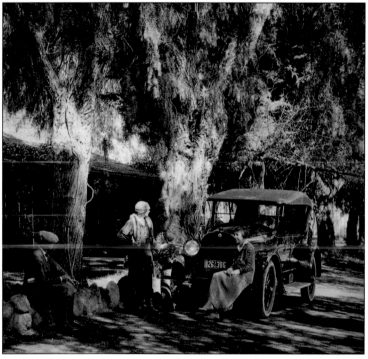

OSUNA 2, A CHAT WITH THE ARCHITECT. In full 1920s garb, ranch residents and personnel have a chat with architect Lilian J. Rice (seated on the car). A very easygoing atmosphere prevailed at the Osuna 2. While the conversations continue, the village core, which consisted of the Santa Fe Land Improvement Company office block, the garage block, and the guesthouse, are all simultaneously under construction.

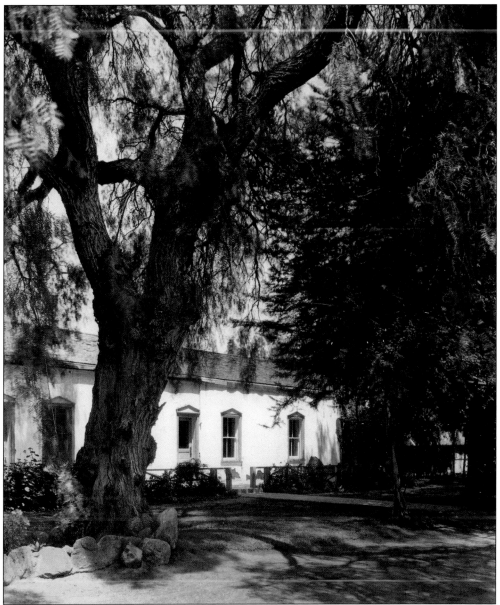

Osuna 2, Main House. Osuna 2 was built much like Osuna 1, with thick adobe walls and deep recessed windows. After the death of Osuna in 1847, his widow, Juliana, lived here until her death. In 1872, it remained in Osuna's ownership until the Santa Fe Railway purchased the grant in 1906. A succession of landowners added smaller buildings to the property. One notable owner, actor and crooner Bing Crosby, his wife, Dixie, and their children lived here part-time during the late 1930s and early 1940s. Rancho Santa Fe architect Lilian J. Rice was commissioned by Crosby to rehabilitate the original adobe as a guesthouse. Lilian also designed a new house on the property for a private Crosby residence.

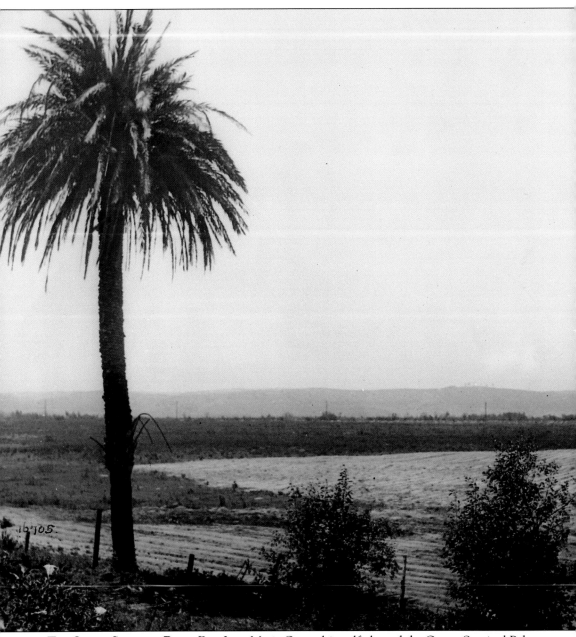

THE OSUNA SENTINEL PALM. Don Juan Maria Osuna himself planted the Osuna Sentinel Palm. Lore persists that he obtained the palm from the Mission San Juan Capistrano and brought it to Rancho San Dieguito in the 1840s in a fairly mature state. The Spanish brought *Phoenix dactilyfera*, or the date palm, to the New World. Fr. Junipero Serra planted a cluster of them at the foot of El Presidio Réal de San Diego in the 1770s, later called the Serra Palms. The date palm naturally occurs in Egypt along the Nile River and was introduced throughout the Mediterranean. The palm fronds are used in religious rituals on Palm Sunday. It is believed that the Spanish missionaries planted these palms near mission and pueblo sites as way-finding tools, much like a street sign is used today.

Two

THE EUCALYPTUS EXPERIMENT
AND A CHANGE OF COURSE

Worried that the supply of domestic timber would diminish the Santa Fe began an experimental
program that would cultivate eucalyptus in order to use its wood for railroad ties.

—Lauren Farber, architectural historian, HABS Project, 1991

In 1906, the Santa Fe Railway launched its ambitious eucalyptus tree farm meant to produce millions of board feet for railroad ties. Through 1912, three and a half million trees were planted on 3,000 acres near the San Dieguito River. Successful at first, the project slowly began to fall apart. The lack of irrigation and a long drought period weakened the forest. In 1916, there was a significant flood, and many trees were lost in the deluge.

Horticulturists also realized it would take decades to reach maturity to be effective enough for strong ties. Old growth was preferred, and Rancho Santa Fe couldn't wait. In desperation, they found that mature Oregon fir was cheaper, and so the eucalyptus project was quickly abandoned.

Demoralized by the setback, the ranch's Walter E. Hodges considered putting Rancho San Dieguito up for sale. Enter local entrepreneur and land developer Col. Ed Fletcher with a new plan. Between 1916 and 1920, Santa Fe allowed Fletcher land-agent status, and in turn he leased tracts of land to annual crop tenant farmers. Fletcher attempted to demonstrate the potential of the land. It was he who convinced Santa Fe that the property was valuable for agriculture. They saw the wisdom and consequently pursued an agriculture cooperative, thus the concept of the "gentleman farmer" was born.

For such an undertaking, Santa Fe knew a predictable water supply would be essential. Fletcher and William Henshaw, another local entrepreneur, were instrumental in forming the San Dieguito Mutual Water Company, which led to the construction of Hodges Dam, Lake Hodges, and the Santa Fe Irrigation District.

SAN DIEGUITO RIVER VALLEY. This photograph evokes an early-20th-century California landscape, a black-and-white plein air effect. But the Santa Fe Railway wasn't pursuing beauty and art when it planted 3.5 million trees within six years. This was a massive functional project to produce hundreds of miles of board feet for railroad ties.

EUCALYPTUS 10 FEET APART. The trees were planted from seed at approximately 10 feet apart on 3,000 acres near the San Dieguito River. Several species of eucalyptus were studied and selected as the fastest growers. Unknown to the Santa Fe Railway, San Diego's rainfall patterns were unreliable, and without the benefit of irrigation the first years of tree establishment were less than expected.

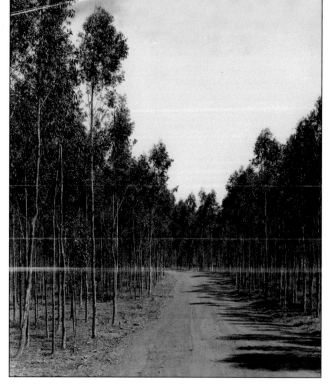

MATURING EUCALYPTUS. Growing at 15 feet per year as heartily as could be expected from eucalyptus, parts of the Santa Fe's plantings were doing well and growing on schedule. However, by 1916, after a torrential rain and posting losses for several years in a row, the project was abandoned. The Santa Fe Railway learned it could obtain Oregon Douglas fir much cheaper. So ended the quick and cheap timber project.

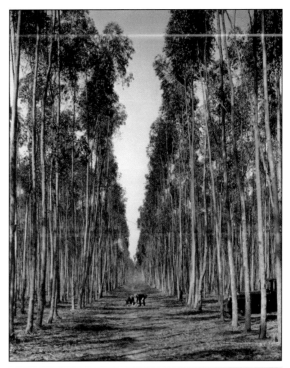

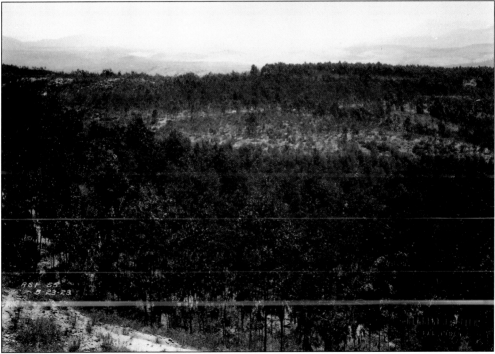

ABANDONED FORESTS. What the Santa Fe Railway left behind was a maturing forest canopy that stretched over much of the Rancho San Dieguito landscape. A decade later, landscape architect Glenn A. Moore would map the boundaries of the ranch's eucalyptus forests. He identified the species and considered the areas as significant horticultural resources.

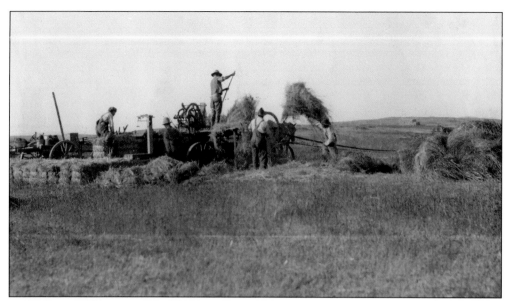

BAILING IN THE FLETCHER PERIOD. From 1916–1920, Col. Ed Fletcher was given land-use control over Rancho San Dieguito. The Santa Fe Railway had lost interest in the land after their eucalyptus experiment proved to be unsuccessful as well as costly. Fletcher leased the land to tenant farmers for annual crops.

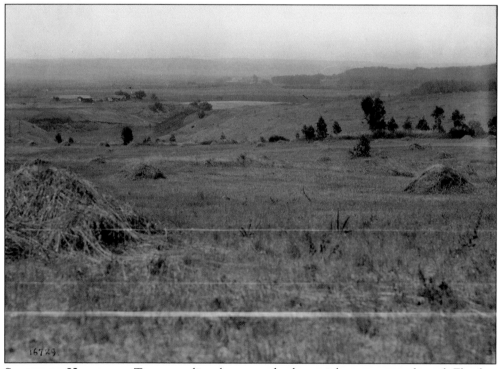

SCATTERED HAYSTACKS. Tomatoes, lima beans, and other quick crops were planted. Fletcher encouraged some farmers to begin planting avocados and a variety of fruit trees to prove to the Santa Fe Railway that the land had great agricultural potential. He was determined to change their course and go from a eucalyptus-based horticulture to an entirely Californian agriculture.

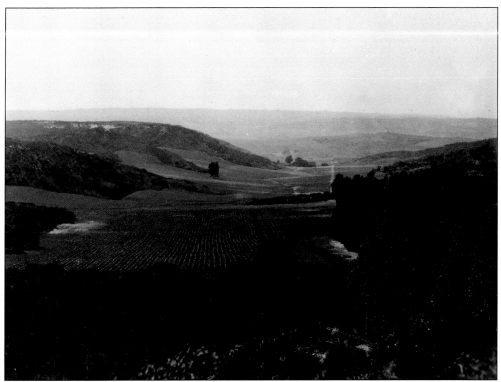

ANNUAL CROPS IN THE VALLEY. The valley floors of Rancho San Dieguito were planted with annual crops. Framed by abandoned eucalyptus, the surrounding forests appear as though they have been carved out to accommodate the open space. Valley floors and other naturally draining areas were the first to be planted because of high groundwater and the best soils.

EARLY CONCRETE WATER RESERVOIR. In the early days, these round reservoirs were placed on all the high points around the ranch providing the necessary water for agricultural crops. A few of these early relics can still be seen in out-of-the-way places on the ranch today.

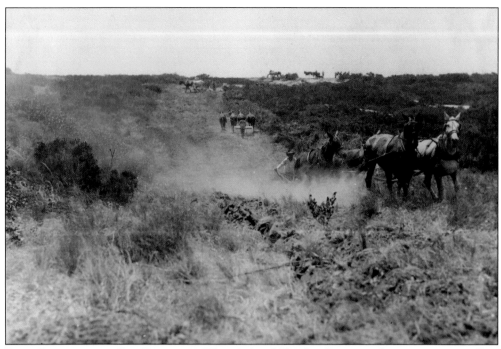

ROAD BUILDING THE OLD-FASHIONED WAY. Colonel Fletcher began road construction to allow for the temporary use of horse-drawn graders on the farm. However, without a comprehensive plan for a road system that would attract investors and potential residents, Fletcher's roads were never fully improved beyond that for rough agricultural uses.

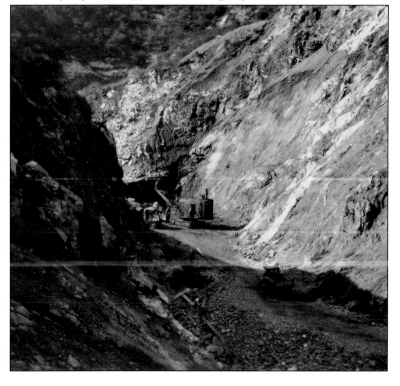

EARLY EXCAVATION OF HODGES DAM. When the Santa Fe Railway committed to its gentleman farmer concept, it knew Rancho San Dieguito would require a significant and predictable source of water. Colonel Fletcher and William Henshaw were instrumental in securing a dam site upstream of the San Dieguito River. Fortunately, the railroad had the financial resources to undertake such a massive project.

Concrete Framing of Hodges Dam.
In 1916, the San Dieguito Mutual Water Company was formed and erected Hodges Dam and Lake by 1918. Directors of the company were W. E. Hodges, W. G. Henshaw, E. O. Faulkner, S. C. Payson, and Ed Fletcher. The engineers were W. S. Post, W. W. Case, G. W. Harris, and Bent Brothers Contractors, and the chief designer was John S. Eastwood.

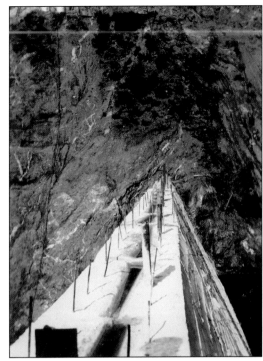

William E. Hodges Surveying the Dam. The design was a concrete 23-arch dam that was 157 feet high and 750 feet wide, which impounded 37,700 acre-feet of water. Lake Hodges covered a watershed area of 253 square miles. Initially it served the Santa Fe Irrigation District, the San Dieguito Irrigation District, Solana Beach, and Del Mar.

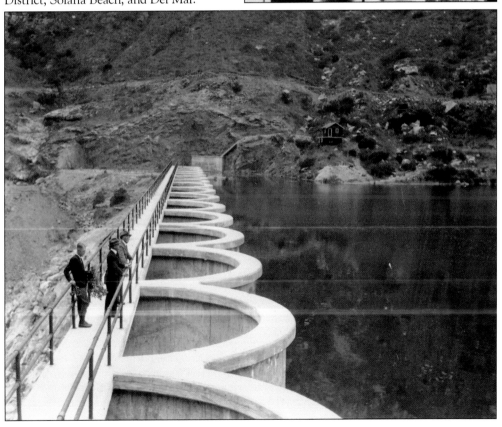

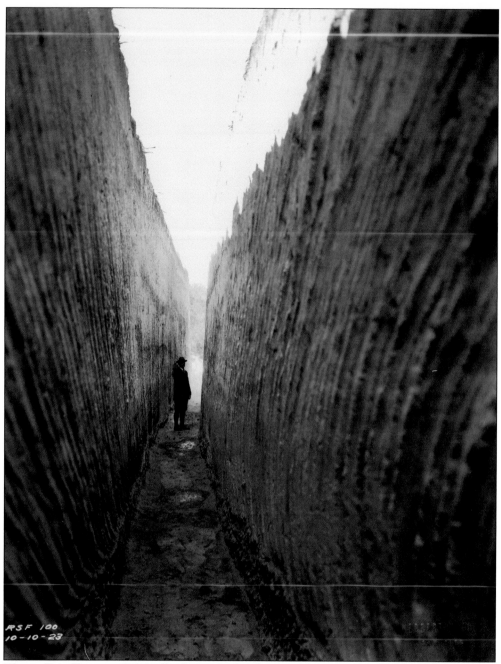

RSF 100
10-10-23

Water Pipe Trench. Originally the water distribution system consisted of steel and concrete pipelines, serving all irrigable parts of the project with concrete reservoirs at strategic points to provide necessary pressure. The attendant San Dieguito Reservoir was built on-site to provide for the distribution of water in a downstream pipeline centered through the ranch and was operated by the newly formed Santa Fe Irrigation District. The new water system eliminated the need for wells and any San Dieguito River agricultural pumping stations. The Santa Fe Railway understood water was a vital element in the success of any community in Southern California.

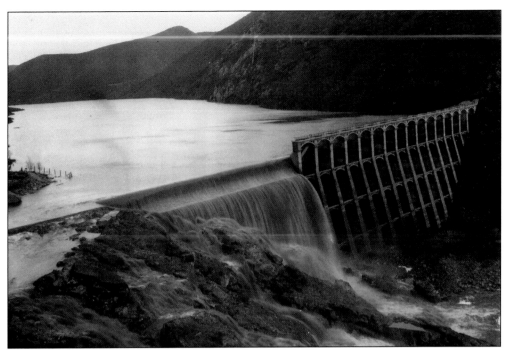

HODGES DAM AND FLOOD OF 1921. After
the construction of Hodges Dam, the design
was criticized by resident cynics. In the
San Diego County flood of 1921, it rained
11.5 inches from December the 18 through
the 27. The dam had been challenged by
nature, and its structural integrity and
overspill capacity had passed the test.

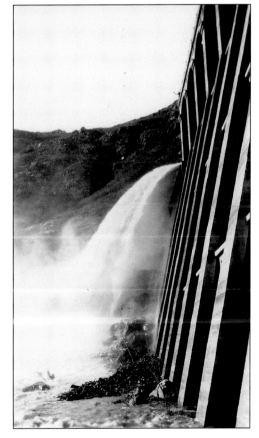

SIDE VIEW OF HODGES DAM OVERSPILL.
According to Colonel Fletcher's memoirs,
the dam recorded an overspill amount of 2.5
billion gallons of water. Although the flood
of 1921 wasn't San Diego's biggest, it was
a timely test to prove the soundness of the
dam's design integrity and construction.

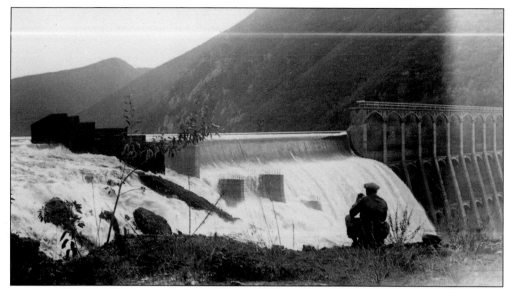

PHOTOGRAPHING OVERSPILL. The Santa Fe, rightfully proud of its heroic lake and dam project, hired Bunnell Photography to document its construction, dedication, and general performance. Bunnell went on to be a major photographer of significant events in San Diego, in particular the 1935 California Pacific Exposition in Balboa Park.

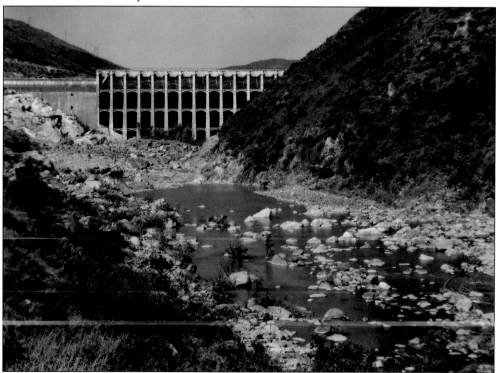

HODGES DAM, 1930s. Years later, Walter E. Hodges wrote on the dissolution of the San Dieguito Mutual Water Company with great appreciation for Col. Ed Fletcher and the role he played in the success of Hodges Dam. Dated July 21, 1924, the letter read, "You are responsible for the development of the Lake Hodges System and of the country it serves."

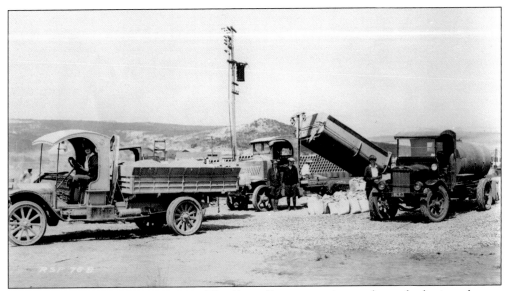

WATER PIPES AWAITING PLACEMENT. The Santa Fe construction yard was the busiest place at Rancho San Dieguito. Underground water infrastructure and road building occupied the Santa Fe Railway team from 1918 through 1922. In their typical style, no expense was spared and every facet of construction was done in a first-class manner.

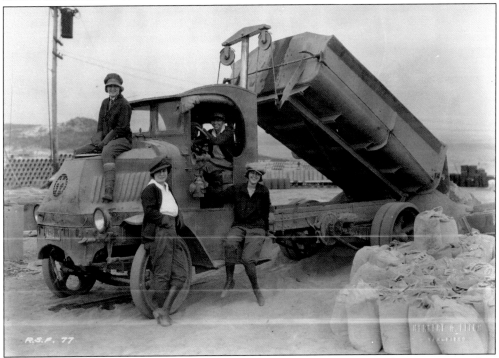

EARTH-MOVING WOMEN. Santa Fe company girls are staged as workers in the construction days of the early project. Rancho Santa Fe architect Lilian J. Rice is seated in the truck, with three friends: Norma McLean sitting on the truck, Virginia Smith standing, and Bertha Kreuziger seated on the running board. All four women actually worked for the ranch and were often staged together in professional photographs by the renowned Herbert Fitch.

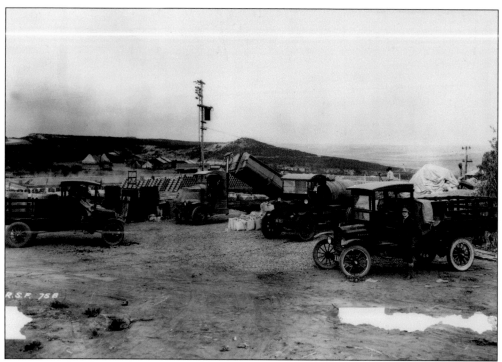

THE SANTA FE YARD. After all the infrastructure and road building was in place, construction began on the commercial core and a few early residences. For a community that was more or less considered an extravagant pipe dream by the Santa Fe Railway, many daring investors and residents cast their lots and bought in on the dream.

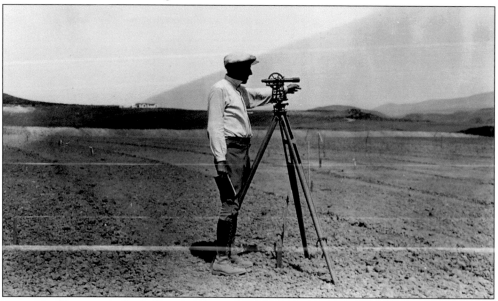

SANTA FE SURVEYOR. Typical to the Santa Fe way, everything was first class. Orchards were engineered, surveyed, and laid out with great precision. Over a mere five years, more than 160 orchards were planted. The orchards were predominantly citrus, the preference of Santa Fe Railway, but also included some avocado and other deciduous fruit.

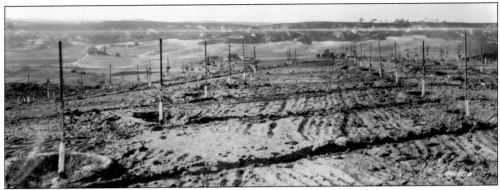

STAKED ORCHARDS. Young trees were treated like gold—planted in the best soils, irrigated in rounded berms, staked, and monitored with great care. This was quite a departure from the hurried planting scheme of the eucalyptus, which were packed closely together nonirrigated and left to fend for themselves. These new orchard trees were given width and breadth for maturity and maximum production.

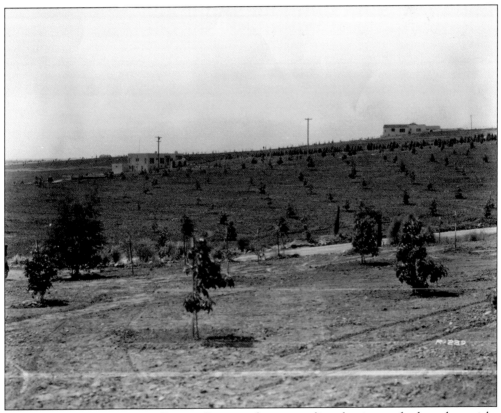

MATURING ORCHARDS AT THE RANCH. Because of expert studies, planting methods, and oversight by professionals, orchard trees were growing at better-than-average rates. Rancho San Dieguito had the best land and climate in California for agriculture. One of the most favored growing climates in all of North America can be found here. This area of San Diego County is often referred to as the "Avocado Belt."

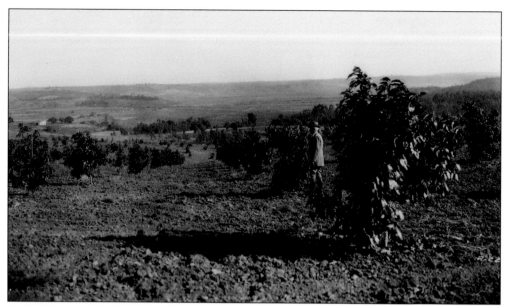

A. R. Sprague Surveys Orchards. Pursuing their interests in "tonnage" and agricultural freight, the Santa Fe formed the Santa Fe Fruit Association. It was an agricultural cooperative that collected, packaged, and transported fruit (citrus) grown on the ranch and shared the profits with the growers. Citrus was marketed through the California Fruit Growers Exchange and avocados through the Calavo Growers of California.

A. R. Sprague and Climate Chart. Santa Fe hired A. R. Sprague as its expert in all things agricultural, and he promoted the cooperative. He wrote, "Briefly, the purposes of the organization are to guard the interests of every orchard owner and in every way to secure the greatest possible efficiency and economy in orchard maintenance and the care of fruit."

RANCHO ZORRO RANCH DAM. In 1926, screen actors Douglas Fairbanks Sr. and "America's sweetheart" Mary Pickford purchased a massive 3,000-acre tract of land from the Santa Fe Railway and named it Rancho Zorro. The land was within the old Rancho San Dieguito grant situated on the southeast portion across the San Dieguito River. It was land that the Santa Fe Railway felt was unsuitable to be developed for anything other than agriculture.

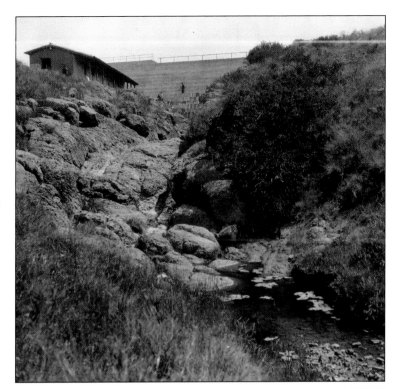

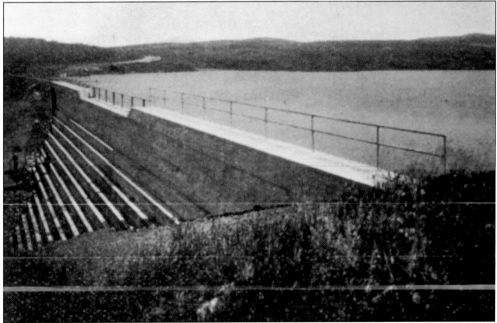

RANCHO ZORRO DAM AND LAKE. Fairbanks built his own dam and lake for irrigation purposes, learning from the precedent set down by the Santa Fe Railway. Valencia oranges were mass-planted throughout the property. He did not realize it would take several years for his orchards to be mature enough to yield edible oranges. To fulfill a promise to send Rancho Zorro Valencias to his European friends, he had to purchase oranges from neighboring orchardists.

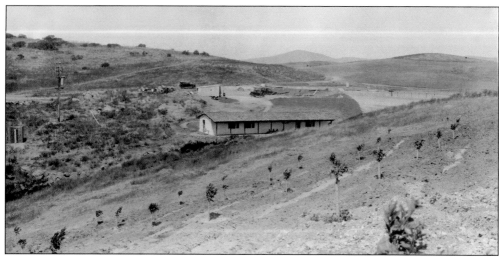

RANCHO ZORRO PUMP HOUSE. This is an early picture of Rancho Zorro. A pump house was constructed, which also housed work hands. Tree planting was fast-paced. Douglas and Mary visited the ranch, always staying at La Morada each time. The couple also owned property in Solana Beach and Del Mar. San Diego County was a great respite away from Hollywood.

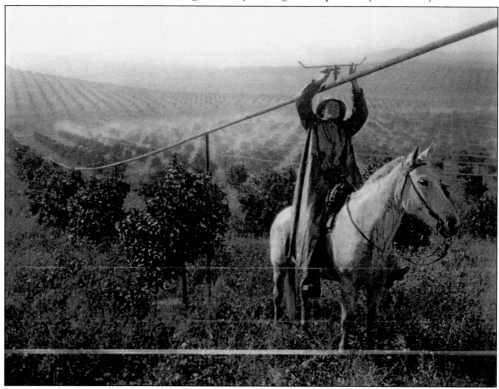

RANCHO ZORRO OVERHEAD IRRIGATION. An innovation at the time, overhead watering was a substitute for rain. The orchards matured at a good rate with this generous water supply. Douglas and Mary planned to build a permanent home at Ranch Zorro. They commissioned architect Wallace Neff to design a hacienda home. Unfortunately they divorced in 1935, and their dream house was never built. (Courtesy San Diego Historical Society.)

AERIAL VIEW OF RANCHO ZORRO. This photograph shows a fully mature citrus orchard encircling Fairbanks's lake and dam. The orchard layout radiates around the lake for efficient water delivery. In the late 1930s, Fairbanks claimed that Rancho Zorro was the largest privately owned citrus orchard in California.

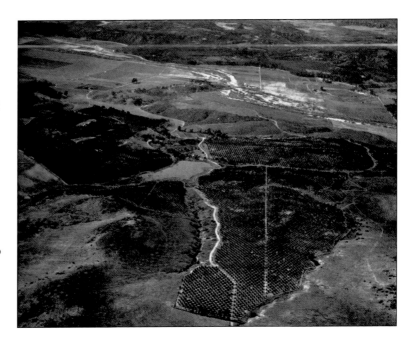

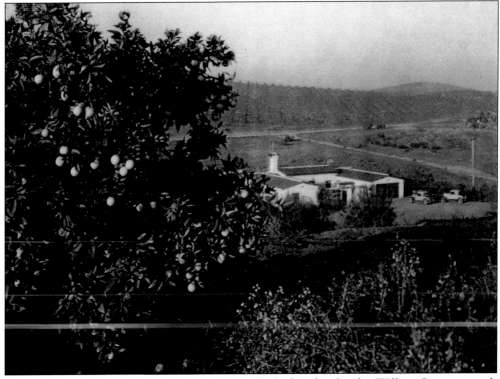

RANCHO ZORRO RANCH HOUSE. Douglas Fairbanks Sr. hired orchardist William Smart as ranch manager. He also had architect Wallace Neff design a residence for the Smart family in the Spanish style. Fairbanks remained involved in ranch operations even after his divorce from Mary Pickford. He passed away in 1939 at the young age of 56.

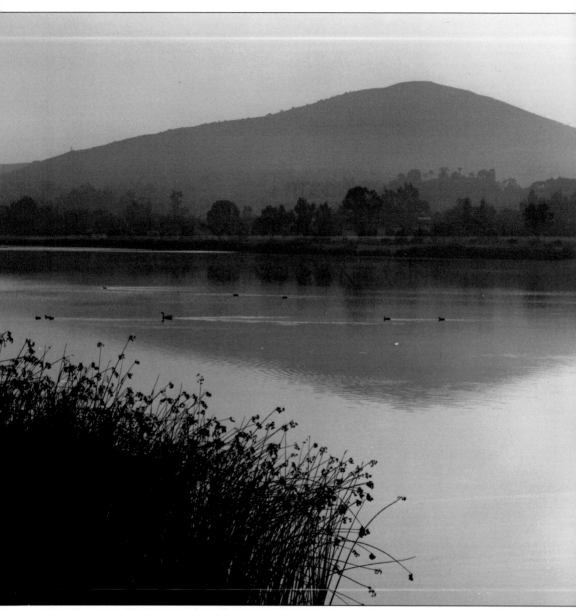

SAN DIEGUITO RESERVOIR. The still waters of the San Dieguito Reservoir evoke images of beauty. The surrounding landscape and hills complete the picturesque composition. Once a functional body for water detainment and delivery, it is now a remnant of the Hodges water infrastructure. Yet fortuitously it is a significant scenic water feature for the ranch. It provides for a rich natural habitat of native flora and fauna, as well as fish and other water species. Much like the abandoned eucalyptus forests that came to be a historic landscape feature of the ranch, the San Dieguito Reservoir also adds character to the overall scenic serenity of Rancho Santa Fe today.

Three
Rancho San Dieguito Becomes "Rancho Santa Fe"

The Santa Fe Land Improvement's first and primary goal should
be an intensive, high-class horticultural development.

—Leone G. Sinnard, land expert

With the eucalyptus project behind it and a new water source in place, it was time for the Santa Fe Railway to reinvent Rancho San Dieguito and recoup its losses. The first thing was a feasibility study for a gentlemen estates community and the formation of the Santa Fe Land Improvement Company, or the "Santa Fe." Walter E. Hodges turned to a noted land expert, formerly of the Southern Pacific Railroad, Leone G. Sinnard.

Sinnard joined the team in early 1921. His development survey, "Proposed Subdivision of Rancho San Dieguito," evaluated the feasibility of an agriculturally productive, residential community. Sinnard surveyed land parcels, designed road systems, and drew up a civic center later known as the village. In December 1922, the newly formed Santa Fe Land Improvement Company filed a subdivision map for Rancho Santa Fe, forever retiring the name of Rancho San Dieguito.

Sinnard was given full control over all aspects of the project. He was responsible for hiring the architectural team of Requa Jackson, which included the talented Lilian J. Rice, expert agronomist A. R. Sprague, landscape architect Glenn A. Moore, and others. The Santa Fe Railway was known for obtaining the top experts in their respective fields.

Camped out in the adobes and ranch houses at old Osuna 2, the Santa Fe began construction of the project. By 1924, the Santa Fe's office block, a garage block, a guesthouse, and the restoration of Osuna 1 were completed. Sales of parcels moved slowly but steadily. Santa Fe required new property owners to build homes within the first year of purchase, or put at least a third of their property into orchard cultivation. The ranch was starting to realize its destiny.

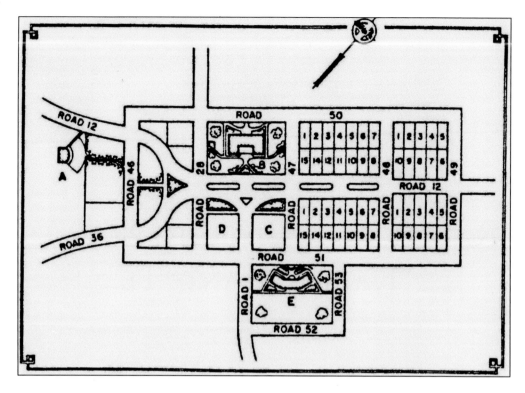

TWO VERSIONS OF THE CIVIC CENTER. The first depiction of the Rancho Santa Fe's central core was drawn by engineer Leone Sinnard in 1921. It shows a closed road pattern, an open-air theatre, a hotel, store, garage, and school. After the architectural firm of Requa and Jackson was hired in 1922, the civic center plan was revised. With the expertise of Requa and his design partner, Lilian J. Rice, the engineered design was softened and artfully illustrated. The hotel, or guesthouse, was moved to the high point around a park area; the school was moved into the center of town. A much larger Santa Fe Land Improvement Company office block and garage block were designed.

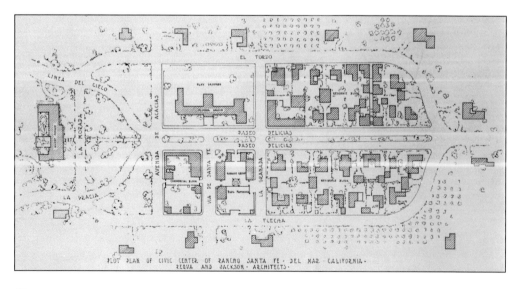

ENGINEERED SUBDIVISION MAP.
The first Rancho Santa Fe
subdivision map was filed at the
County of San Diego in December
1922. All roads, land parcels,
the civic center, and property
boundaries were surveyed and
drawn to specifications. The
company retired the name Rancho
San Dieguito for its namesake.

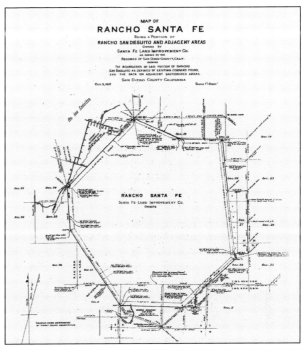

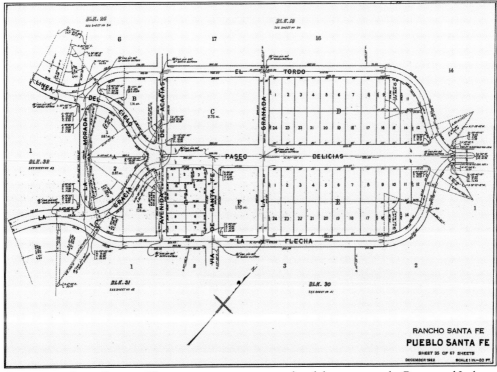

ENGINEERED CIVIC CENTER. The civic center was surveyed and drawn as per the Requa and Jackson architectural firm. The hard edges of the roads were rounded for easier automobile access. The commercial and public areas were clustered together. Several small residential lots were provided for those who wanted to live in town.

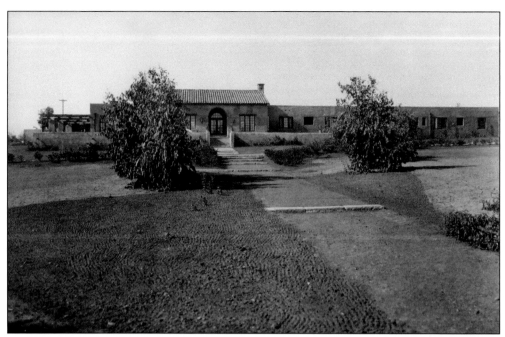

GUESTHOUSE FOR PROSPECTIVE INVESTORS. One of the first photographs of the guesthouse and grounds, later named La Morada, is shown here. Potential buyers would travel on the Santa Fe Railway, then ride in a car to the ranch, and ultimately enjoy the hospitality of the guesthouse built specifically to accommodate and impress investors.

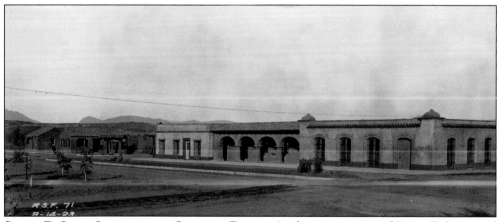

SANTA FE LAND IMPROVEMENT COMPANY BLOCK. At the intersection of Paseo Delicias and Avendia de Acacias was the Santa Fe Land Improvement Company office block. It consisted of two buildings attached by an arched corridor with a courtyard behind. It is believed that Richard Requa contributed to the design of the ranch's office. Early tree planting and the Paseo Delicias median are present.

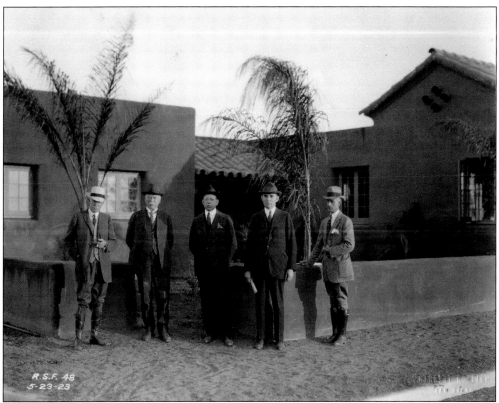

A Visit from the Santa Fe Brass. In this photograph are, from left to right, Walter E. Hodges, Santa Fe Railway vice president; E. P. Ripley, president; E. J. Engle, secretary; an unidentified man; and Leone G. Sinnard, ranch engineer. This photograph, taken in 1923, shows the first few buildings had been completed. This structure was a residential portion of the garage block.

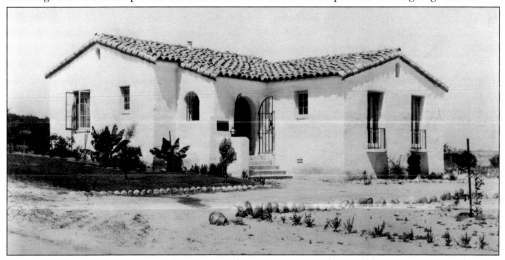

Santa Fe Irrigation District Building. This structure was designed by Lilian Rice in the new Rancho Santa Fe style. At its formation in 1923, the district consisted of 8,374 acres, including 6,200 acres of Rancho Santa Fe, the town of Solana Beach, and a portion of the area between Rancho Santa Fe and the Pacific Ocean. William Boettiger was the first manager of the district.

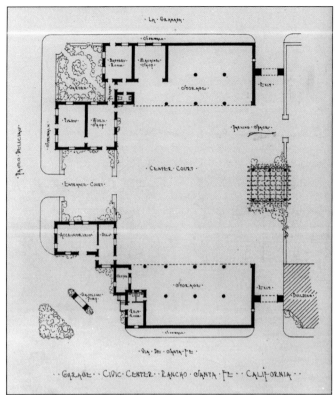

GARAGE BLOCK. In the heart of the commercial area, the garage block was an essential resource for new residents and their leisure cars. It consisted of a gasoline pump that resembled a wishing well, a wash rack, battery room, oils, accessories, tire workshops, a machine shop, restrooms, ample storage areas, and a central court. At one point, a Studebaker dealership had an office in one of the rooms. The accessories room gave way to a lunchroom, and the far end, where a large garden was planted, became the residence of Louise Badger, once married to R. E. Badger, a Santa Fe orchardist.

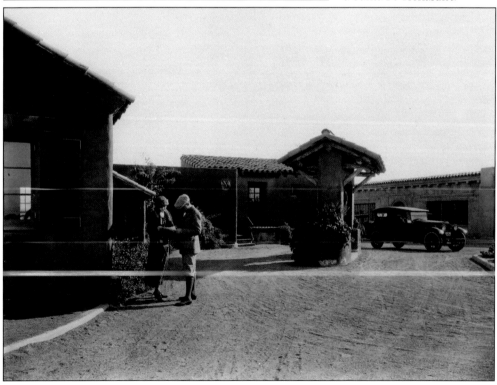

GARAGE BLOCK ARCH. Even the exit from the garage block was a beautiful piece of architecture. Keeping the style specific to Rancho Santa Fe, every aspect of the ranch was well designed and thoughtfully considered. Lilian Rice was the primary architect by this time, and her attention to detail, function, and aesthetics was present in all her work.

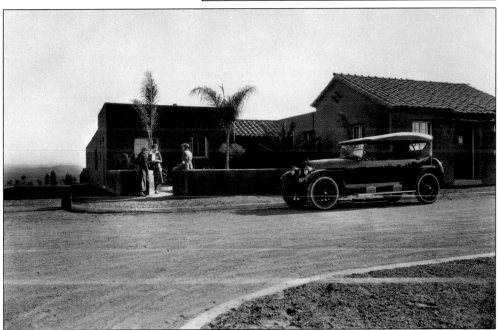

THE LOUISE BADGER HOUSE. Once part of the garage block, this corner later became the temporary home of Louise Badger. The only boarding in the civic center at the time would have been in the guesthouse, which was meant to accommodate prospective investors and future residents of the ranch.

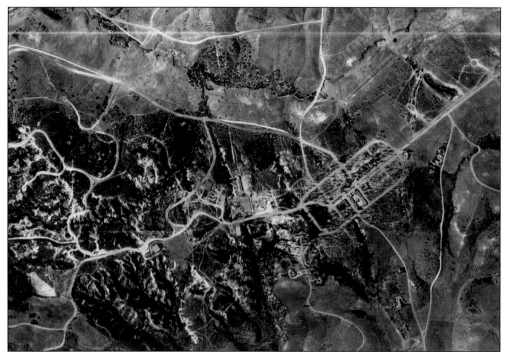

1928 AERIAL OF THE VILLAGE AREA. This photograph shows the civic center at the beginning of its expansion. Roads leading into the center from the left and clockwise are Linea del Cielo, La Granada, Avenida de Acacias, Paseo Delicias (going toward the Hodges Dam), Via de la Valle, Via de Santa Fe, and La Gracia.

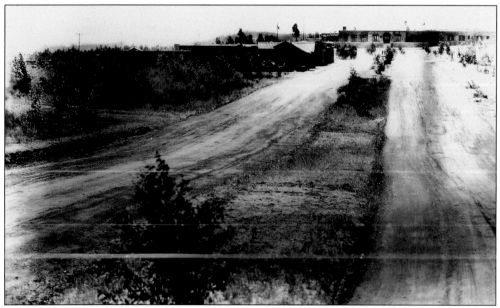

LOOKING DOWN PASEO DELICIAS. One of the first photographs of Paseo Delicias, a separated boulevard with unimproved medians, is shown here. The garage block is also visible as is La Morada in the distance. In 1923, there was very little landscape, but the bones of the village were beginning to emerge.

COMPANY GIRLS AT LA MORADA. Another staged photograph by Herbert R. Fitch, a noted professional hired by the ranch to capture all phases of the making of Rancho Santa Fe, is shown here. From left to right are Lilian Rice, ranch architect; (seated) Norma McLean and Bertha Kreuziger; and Virginia Smith—all secretaries employed by the Rancho Santa Fe.

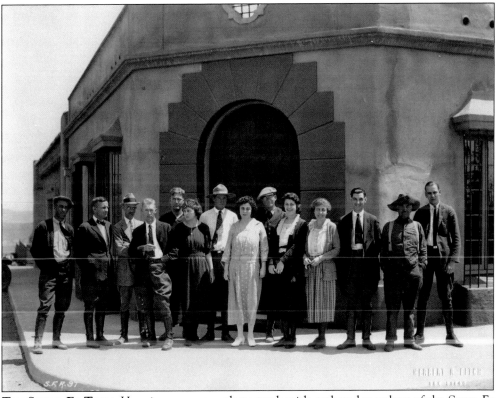

THE SANTA FE TEAM. Here is a company photograph with gathered members of the Santa Fe team. The third person from the left is Leone G. Sinnard; in the front are the four company girls again, with Lilian Rice on the right; the tall man on the far right is William Boettiger of the Santa Fe Irrigation District; all others are unidentified.

NEW RESIDENTS AT THE GUESTHOUSE. The air of leisure and privilege can be felt at La Morada. The south patio and lawn was a favorite gathering spot that highlighted the indoor and outdoor lifestyle available to those who lived in Southern California, and in particular Rancho Santa Fe. In the distance, trees planted are starting to gain height.

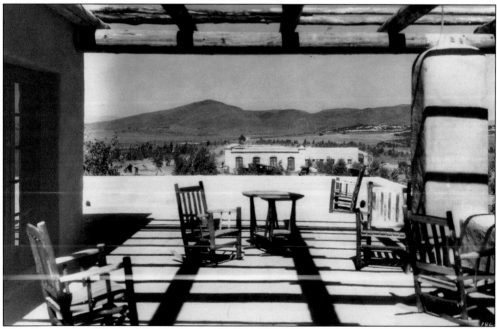

THE GUESTHOUSE PATIO. La Morada patio is absent of guests for this photograph but was always a place of respite for visitors, equestrians, and tennis players. In the background, the Santa Fe Land Improvement Company office block stands as a beacon in the landscape. In the distance, the surrounding mountains complete the picture.

SELLING RANCHO SANTA FE. The marketing of Rancho Santa Fe was its own project. The ranch had sales offices in Los Angeles and on the ranch. Relationships with newspapers, like *the Los Angeles Times,* and many periodicals of the day boasted full-page ads extolling the beauty and opportunities that could be found at "Rancho Santa Fe: California's Perfectly Planned Community."

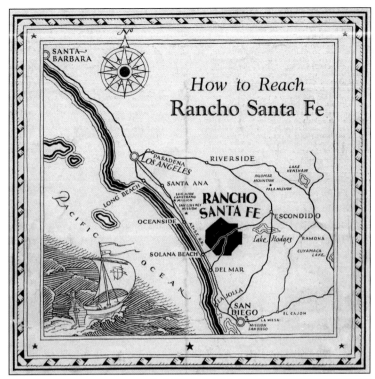

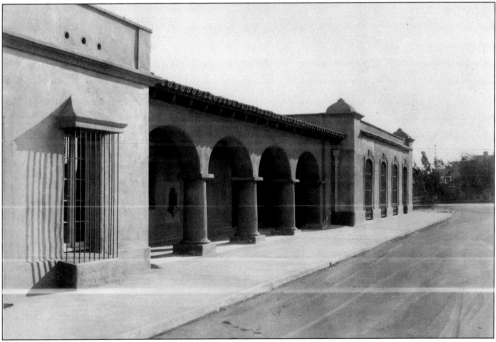

SANTA FE LAND IMPROVEMENT COMPANY BLOCK. Architectural eclecticism was illustrated at Rancho Santa Fe. The Francisco Building in the foreground has Mexican-influenced grilled windows that Lilian Rice used frequently. The arched corridor is classic Spanish Revival. At the end of the block, the Santa Fe offices have an exotic Moorish appearance.

FLORENCE CHEYNE, HOSTESS OF LA MORADA. Florence Cheyne was known to be a gracious hostess, looking after each guest with a personal touch. La Morada was the social focal point of the Rancho Santa Fe Village. Brilliantly sited on a rise at the terminus of Paseo Delicias, it offered one a panoramic view of the surrounding picturesque landscape, which only enhanced the experience for guests. Prospective investors and residents, which included noted businessmen and movie stars, were all treated with sophisticated ranch-style hospitality. Screen actors Douglas Fairbanks Sr. and Mary Pickford made La Morada their home away from home while visiting their beloved Rancho Zorro.

Four

THE SANTA FE
LAND IMPROVEMENT COMPANY

*The most perfectly planned land project in the world . . . already has progressed far enough
to make it appear certain that the dreams of its planners are to be realized in full.*

—H. Lee Shippey, contributing editor, *Los Angeles Times*, 1923

The new community of Rancho Santa Fe was taking shape. The Santa Fe Land Improvement Company
carefully documented its progress and began an aggressive sales campaign. It targeted the East Coast
and upper Midwest, yet most of the first purchases came from Los Angeles and Chicago.

Santa Fe's sales pitch conjured a peaceful romantic image of "winding drives, shady trails, wooded
knolls, ocean vistas, beautiful flower gardens, landscaped walks, rose-covered pergolas, and the
'witchery' of friendly old California mountains." It assured the potential investor and resident of
more than enough water in nearby Lake Hodges, underground utilities, and fine surfaced roads.

Brochures boasted of thousands of thriving trees and avocados, lemons, Valencia oranges,
apricots, grapes, and walnuts, all well adapted to the fertile soil of the ranch. Furthermore, to
ensure appropriate development, "Each purchaser is required either to plant one third of his
acreage to suitable fruit trees or to build his home within one year. No home costing less than
$5,000 can be constructed, and in some localities it must cost not less than $15,000." The land
was sold at cost plus 15 percent for improvements.

Aside from architect Lilian Rice and engineer Leone Sinnard, other professionals also contributed
to the ranch. Glenn A. Moore became the resident landscape architect. He also operated the
ranch's first nursery in the heart of the civic center. Moore guided those new to California in all
horticultural practices and said, "The work of the landscape architect is comparable to that of
the goldsmith in that it furnishes the setting for the jewel."

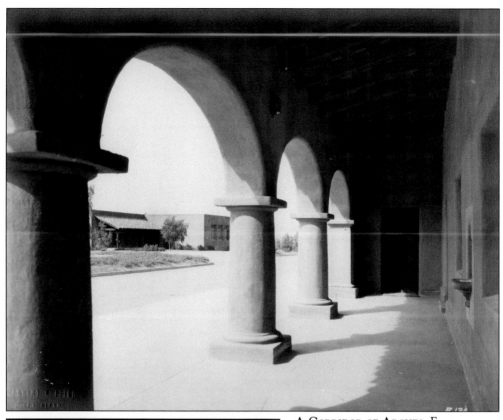

A Corridor of Arches. Four arches line the corridor between the Rancho Santa Fe office and the Francisco Building. Behind the wall is a protected courtyard that accessed both buildings. It held the first plant nursery of ranch landscape architect Glenn A. Moore. Across Paseo Delicias and framed by the arch is a view of the school group buildings.

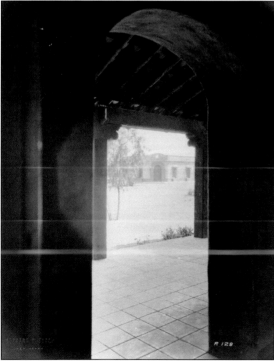

View from the School Group. From the corridor and arch of the school buildings one can see the Francisco Building across Paseo Delicias. The school was situated in the center of town, a gesture made by a strong advocate for education, architect Lilian Rice. It then moved out of this complex in the mid-1930s and became the village post office.

Garage Block Entry. The Badger residence flanked one side of the Paseo Delicias entry into the garage block, and the lunchroom was on the other side. This black and white photograph shows a medium hue for the buildings, which alludes to the plaster, or exterior paint, being of a deep color. If the building was actually white, it would have photographed as such. It is believed that the Santa Fe, as well as Lilian Rice, preferred a mixed color scheme on the village buildings. Those colors would have been typically earth tones, such as ochres, rusts, and tan colors for which the ranch was most known.

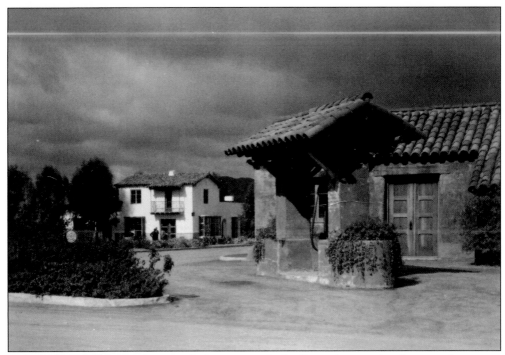

GARAGE BLOCK FILLING STATION. In keeping with the Spanish revival style, even the garage block took on romantic tones. The gas filling station here resembles a wishing well with a tiled roof that matches the surrounding architecture. The Joers-Ketchum commercial building can be seen across Paseo Delicias in the distance.

THE JOERS-KETCHUM BUILDING. One of the first commercial buildings hosted a tearoom and studio on the northwest corner of Paseo Delicias and La Granada (Pomegranate). The Joers-Ketchum Building, named for successional owners, was the first two-story building in the village. The owners chose not to join the Rancho Santa Fe Protective Covenant, although today this building is one of the most intact Lilian Rice buildings.

LOOKING FROM LA MORADA. Looking down Paseo Delicias, a maturing landscape framed by eucalyptus trees and distant mountains is visible. Santa Fe landscape architect Glenn A. Moore began landscaping the village at the same time the buildings were being constructed. Each historical photograph shows a graduating level of maturity throughout the years.

LA MORADA INN. La Morada was originally built to accommodate prospective investors, but it also housed long-stay visitors and vacationers. The publicity surrounding the newly planned community and the long dry period during the Prohibition years attracted many travelers from Los Angeles on their way to Mexico to legitimately order a cocktail.

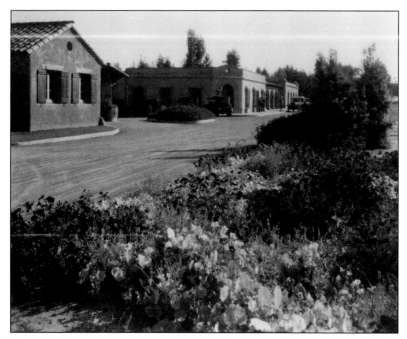

PASEO DELICIAS AT GARAGE BLOCK. The foreground shows a generously planted bed of floral color in keeping with the name of the street, Paseo Delicias, which means "delightful walk" in Spanish. The naming of the roads of Rancho Santa Fe played into the romanticism as did the architecture and floral displays.

VIEW WEST ON PASEO DELICIAS. Looking toward La Morada in 1940, this photograph shows a manicured streetscape. The landscaped, park-like median separates Paseo Delicias into a boulevard down the center of town. The village appears quiet. Rancho Santa Fe wasn't spared during the Depression of 1930s. Growth and real estate transactions came to a near standstill.

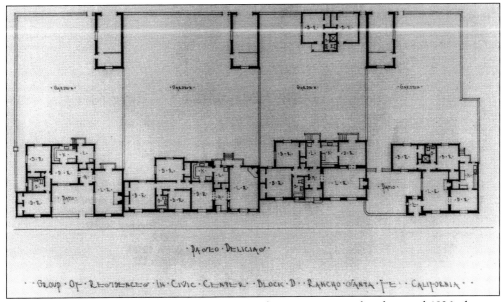

ROW HOUSES DRAWINGS. When the Lilian Rice designs were completed around 1926, the row houses were originally intended for company folks. The first occupants were, from left to right, Spurr-Clotfelter, La Morada manager; Sydney and Ruth Nelson, ranch managers; Baker-Megrew, postmaster; and Glenn A. and Ida May Moore, landscape architects.

COMPLETED ROW HOUSES. This layout of the first four attached dwellings at Rancho Santa Fe seemingly rambles with undulating facades, as would an ensemble of Old World Spanish village homes. Lilian Rice mastered the nuances of the style as if they were built separately over time and with different materials and colors.

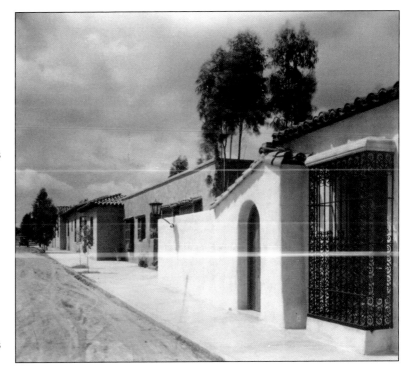

59

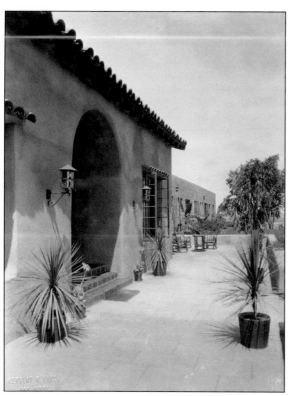

LA MORADA ENTRY PATIO. La Morada was the central focus of Rancho Santa Fe. The Santa Fe operated the hotel until 1931. A. R. Bishop ran it until 1939, when it changed hands to George Roslington until 1941. George Richardson purchased and renamed it The Inn. Reg Clotfelter managed it during his ownership and directed a significant expansion.

LA MORADA MAIN ENTRY. With its signature arch entry, La Morada looked out over the village and distant panoramic vistas. In an article in *Rancho Santa Fe Progress*, entitled "Visitors from Everywhere," it listed the cities from all over the country of each guest. Winter visits seemed to peak in February, as noted by hostess Mrs. Cheyne.

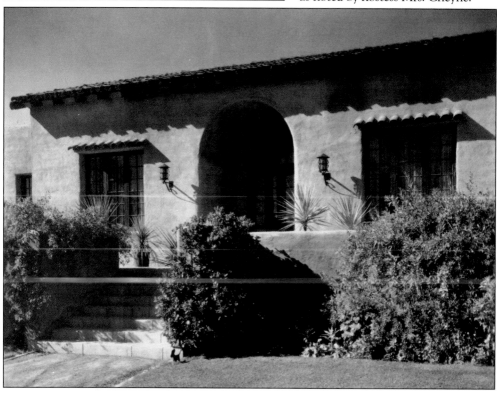

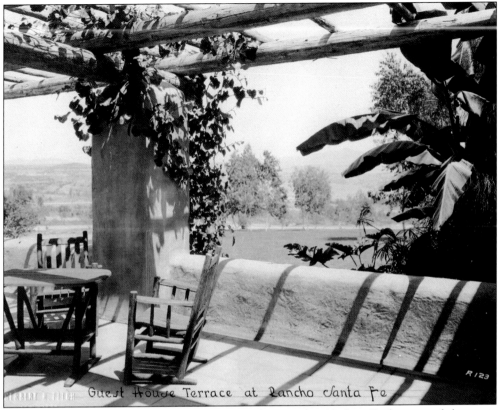

Guest House Terrace at Rancho Santa Fe

LA MORADA SOUTH PATIO. Santa Fe Company photographer Herbert Fitch captured the rustic simplicity of the architecture, landscape, and vistas in every composition. Most pictured were the guesthouse (La Morada) and the south patio, which became a main outdoor gathering spot.

LA MORADA PATIO TRELLIS. The picturesque trellis over the south patio at La Morada was constructed of eucalyptus wood, of which there was plenty on the ranch. Mimicking the willow furniture styles of East Coast rural estates, the eucalyptus was an excellent substitute and a good use of the remnant forest.

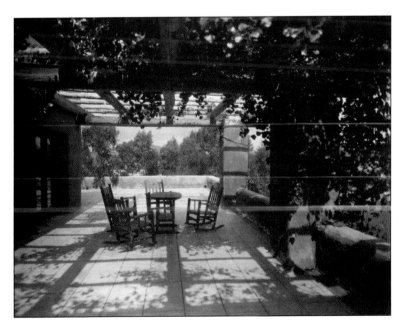

61

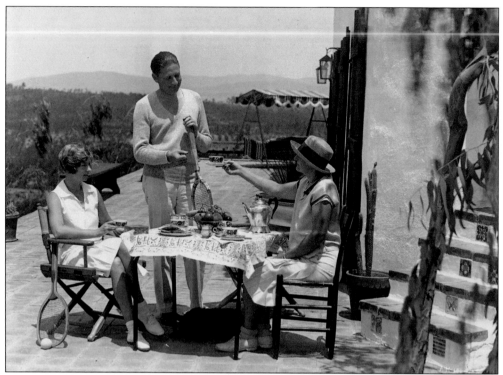

GUESTS AT THE PAULINE NEFF RESIDENCE. Silent film star Pauline Neff entertained guests, many of whom were not from California. The year-round indoor-outdoor life was a luxury. The ranch published climate statistics as a major part of its selling strategy. Its ads read, "Free from the wind, fog and rain, warmer in winter, cooler in summer, and undergoes less change between day and night than any other region on the continent."

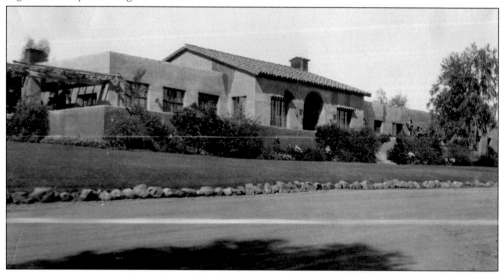

LA MORADA ORIGINAL ENTRY ROAD. The road that passed by La Morada was part of the original road system designed by L. G. Sinnard and refined by Lilian Rice. Named La Morada (the home), it once connected Linea del Cielo (Line of the Sky) and La Gracia (Road of Beauty) and was convenient for vehicular access to the hotel.

THE ENDLESS MIRACLE, LA MORADA ARCH. Each photograph composition had the potential of being a magazine cover. In this case, the August 1927 issue of the *Endless Miracle*, a Santa Fe publication, features the scenic view down Paseo Delicias of the beautiful Village of Rancho Santa Fe.

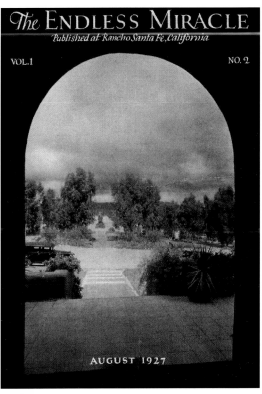

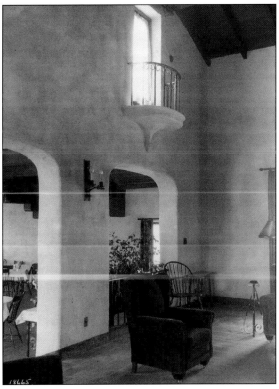

LA MORADA, LOBBY BALCONY. Architectural eclecticism occurred in interior designs as well as exterior. As shown in this photograph, a second-level faux Spanish balcony hosts a window that in turn acts as a light source for the lobby. Simplicity, authenticity, and function were adhered to in all aspects of architectural design.

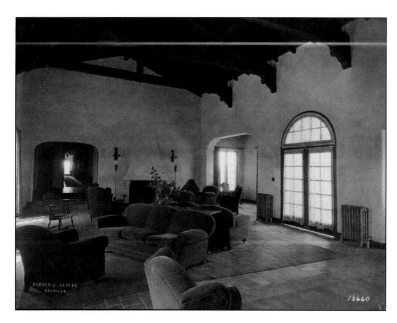

LA MORADA, COZY LOBBY. Although appearing sparse by today's standards, the lobby at the La Morada was a central comfort zone. Hostess Florence Cheyne was quoted as saying, "The entire idea of La Morada is that our guests shall feel they are not in a public inn but rather enjoying the comforts and pleasures of a well-regulated home."

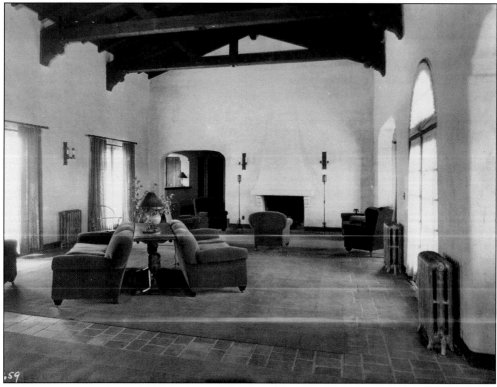

LA MORADA, LOBBY INTERIOR. The La Morada lobby is shown at a time without any social interaction. Yet it became so popular that expansion of the hotel and grounds occurred soon after the Santa Fe period ended by the 1930s.

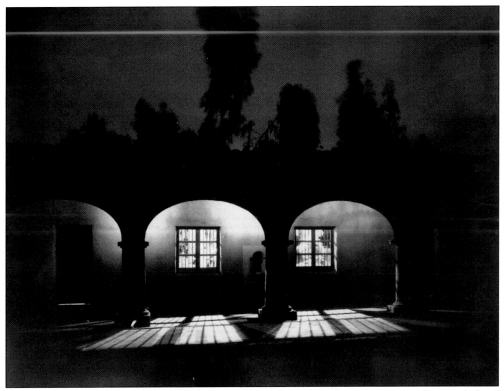

ARCHES AT NIGHT. In a beautifully staged night photograph, the composition shows a lighted courtyard that emphasizes the arched corridor between the Santa Fe Land Improvement Company offices and the Francisco Building. However, Rancho Santa Fe put in place a dark-sky policy that continues today.

GRILLED SCREENS AND RUSTIC DOORS. Alhambra-like doors, reminiscent of Andalusian Spain, further the cultural traditions that are made possible by such attention to architectural details. All construction was fabricated on-site, and not from European salvage, effectively evoking an instant Old World feeling.

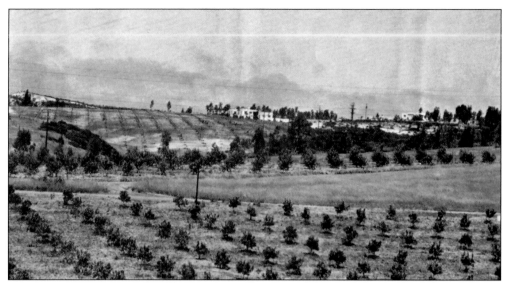

EMERGING ORCHARDS AND ARCHITECTURE. Santa Fe orchardist U. L. Voris reported planting statistics through 1928 consisting of 473 acres of Valencia oranges, 436 acres of avocados, 175 acres of lemons, 72.5 acres of walnuts, and 20 acres of assorted deciduous fruit trees. He wrote that 15,000 trees were on immediate order. Estate residences were planned equidistant to one another and were surrounded by orchards as per the requirements of the Santa Fe. The Rancho Santa Fe Fruit Association was established to "guard the interests of every orchard owner." Yields from each orchard and profits were shared among its members during the Santa Fe period. The directors were C. F. Pease, president; Ranald Macdonald, vice president; and Edward White, secretary. A. R. Sprague was the administrator and counsel.

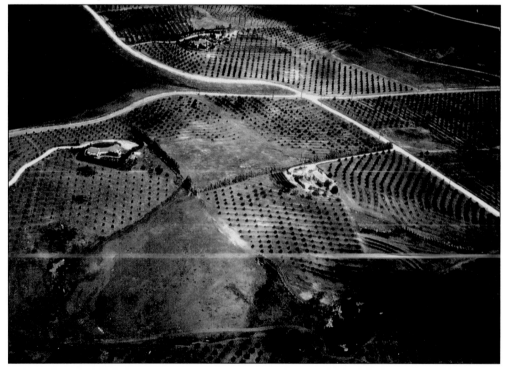

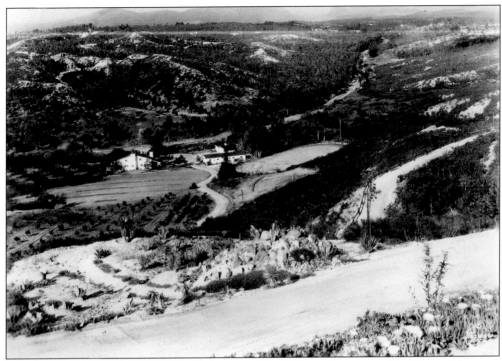

UNDULATING TOPOGRAPHY. The natural topography of the ranch was considered one of the most character-defining elements of the landscape. From inception, large-scale grading was disallowed. That land ethic continues today as codified in the Rancho Santa Fe Protective Covenant and applies to all construction.

MATTOON ACT BOND BURNING, MID-1930S. Rancho Santa Fe Association member O. A. Moxness feeds the fire with bond paper. Sydney R. Nelson, ranch manager, is behind the bond burner's right hand. Ruth R. Nelson, at left in the front row, is in a light coat. The Mattoon Act was an assessment device that provided monies for the maintenance of rural road systems.

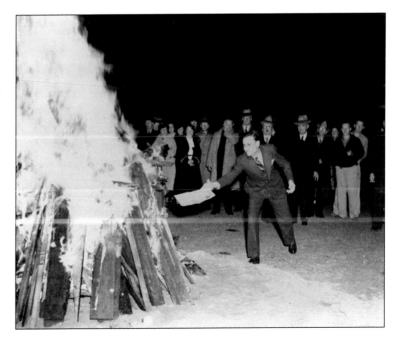

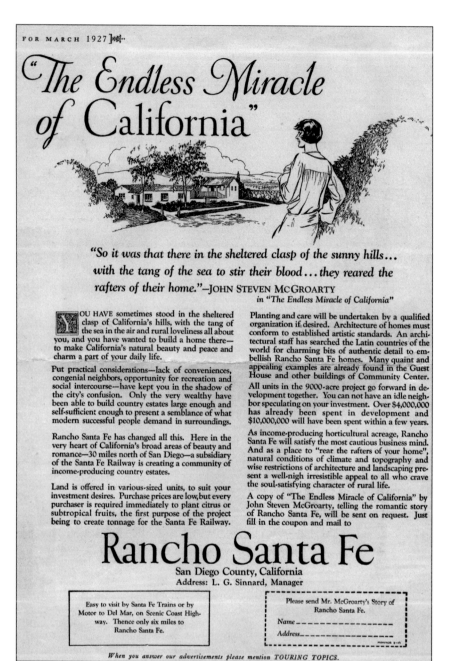

"The Endless Miracle of California"

"So it was that there in the sheltered clasp of the sunny hills...
with the tang of the sea to stir their blood... they reared the
rafters of their home."—JOHN STEVEN MCGROARTY
in "The Endless Miracle of California"

YOU HAVE sometimes stood in the sheltered clasp of California's hills, with the tang of the sea in the air and rural loveliness all about you, and you have wanted to build a home there—to make California's natural beauty and peace and charm a part of your daily life.

Put practical considerations—lack of conveniences, congenial neighbors, opportunity for recreation and social intercourse—have kept you in the shadow of the city's confusion. Only the very wealthy have been able to build country estates large enough and self-sufficient enough to present a semblance of what modern successful people demand in surroundings.

Rancho Santa Fe has changed all this. Here in the very heart of California's broad areas of beauty and romance—30 miles north of San Diego—a subsidiary of the Santa Fe Railway is creating a community of income-producing country estates.

Land is offered in various-sized units, to suit your investment desires. Purchase prices are low, but every purchaser is required immediately to plant citrus or subtropical fruits, the first purpose of the project being to create tonnage for the Santa Fe Railway.

Planting and care will be undertaken by a qualified organization if desired. Architecture of homes must conform to established artistic standards. An architectural staff has searched the Latin countries of the world for charming bits of authentic detail to embellish Rancho Santa Fe homes. Many quaint and appealing examples are already found in the Guest House and other buildings of Community Center.

All units in the 9000-acre project go forward in development together. You can not have an idle neighbor speculating on your investment. Over $4,000,000 has already been spent in development and $10,000,000 will have been spent within a few years.

As income-producing horticultural acreage, Rancho Santa Fe will satisfy the most cautious business mind. And as a place to "rear the rafters of your home", natural conditions of climate and topography and wise restrictions of architecture and landscaping present a well-nigh irresistible appeal to all who crave the soul-satisfying character of rural life.

A copy of "The Endless Miracle of California" by John Steven McGroarty, telling the romantic story of Rancho Santa Fe, will be sent on request. Just fill in the coupon and mail to

Rancho Santa Fe

San Diego County, California
Address: L. G. Sinnard, Manager

Easy to visit by Santa Fe Trains or by Motor to Del Mar, on Scenic Coast Highway. Thence only six miles to Rancho Santa Fe.

Please send Mr. McGroarty's Story of Rancho Santa Fe.

Name _____

Address _____

When you answer our advertisements please mention TOURING TOPICS.

"THE ENDLESS MIRACLE OF CALIFORNIA." The Santa Fe frequently published advertisements to entice prospective buyers. The narrative writing was always filled with romanticism in describing Rancho Santa Fe. Amenities were listed as well as potential costs set in place by the Santa Fe. Discussions of restrictions and expectations were clearly represented, "Wise restrictions of architecture and landscaping present a well-nigh irresistible appeal to all who crave the soul-satisfying character of rural life." The advertisements deliberately appealed to the soon-to-be-landed gentry with the assurance that they would always be surrounded by other people of means. The ranch was represented as "income-producing horticultural acreage" and never missed an opportunity to emphasize the natural conditions of climate and topography.

Five

THE ARCHITECTURE OF LILIAN J. RICE

*With the thought early implanted in my mind that true beauty lies in simplicity
rather than ornateness, I found real joy at Rancho Santa Fe.*

—Lilian Rice, 1928

Based on its work in Ojai, California, the architectural firm of Requa and Jackson was hired by the Santa Fe. Early on, Richard Requa, the designer in the partnership, worked with Leone Sinnard in developing an architectural style suitable for the new project.

In 1922, Lilian Rice joined the Requa and Jackson firm, recruited by Requa for her known talent and architectural training at the University of California, Berkeley. The timing was perfect, as she was given a managerial role in the early design of Rancho Santa Fe. Requa and Jackson was in its ascendancy and didn't have the time to monitor a modestly growing community with an unknown future several miles out of San Diego.

Lilian Jenette Rice was born in National City in 1888. She was supported by strong-minded parents—her father was an educator and her mother was an artist. In 1910, Lilian returned from Berkeley, one of the first women to secure a degree in architecture. She was a draftswoman for architect Hazel Waterman, daughter-in-law of California governor Waterman. She was exposed to a faithful reconstruction of the Casa Estudillo in Old Town San Diego, a well-researched 1830s adobe, which was an experience that would remain with her and inform her design process later on.

Lilian's design style was informed from her exposure to indigenous earthen architecture, her personal travels to Latin-based cultures, and her time as a student of the classics at Berkeley. She was far more understated in architectural nuance than her peer Richard Requa. Lilian created composite scenes of serenity and quiet beauty reminiscent of a Spanish village.

Lilian Rice was the official supervising architect for Rancho Santa Fe, the first member of the Art Jury, and served on the Rancho Santa Fe School Board. She designed most of the commercial buildings on the ranch and more than 50 estate residences before her untimely death in 1938.

BERKELEY, CLASS OF 1910. Supported by two loving parents, Lilian was an inspired product of their union. She was accepted to UC Berkeley at the age of 17. She embarked on a steamer to the Bay Area in September of 1906, just months after the San Francisco earthquake and fire.

OSUNA 1 RESTORATION. Although Lilian Rice was the Rancho Santa Fe architect, she often did residential and commercial design for ranch residents. The Osuna 1 project was funded by A. H. Barlow, who had a great respect for the Spanish traditions of the area. The fireplace shown in the photograph is one of Lilian's additions, which enabled the small adobe to be habitable.

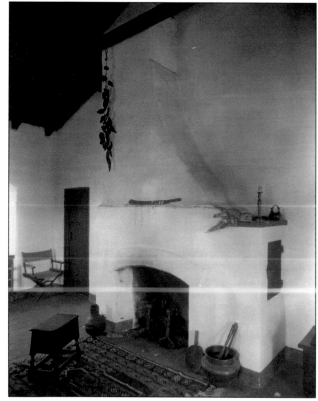

70

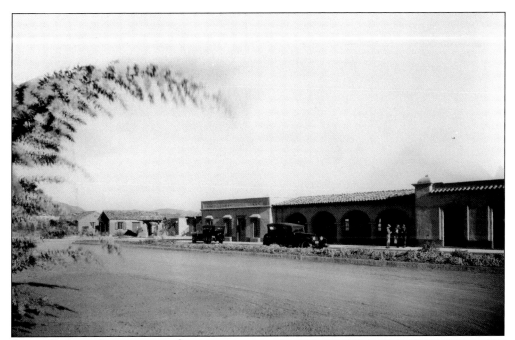

SANTA FE LAND IMPROVEMENT COMPANY BLOCK. The architectural contract was let to the firm of Requa and Jackson. However, Lilian Rice was the project person in charge and on-site representing the firm during the life of the contract. After Requa and Jackson were no longer involved, Lilian became the supervising architect for the Santa Fe Land Improvement Company exclusively.

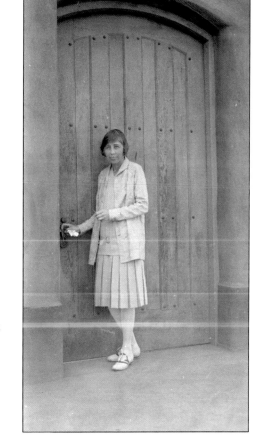

LILIAN RICE AT THE DOOR. The Rancho Santa Fe office shown here was the administrative office on-site. The Santa Fe also had a sales office in downtown Los Angeles where most of the advertising and solicitations for land sales were generated. Moving from the Osuna 2 compound to these offices in the village was a significant step up for officials.

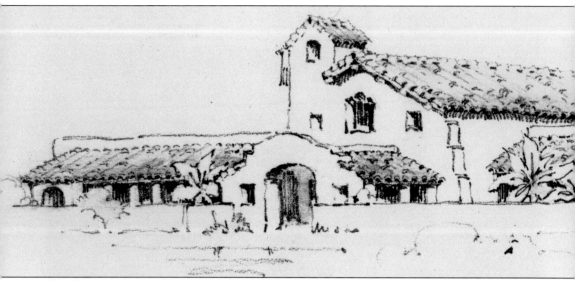

THE RANCHO SANTA FE SCHOOL GROUP. The school group buildings were designed by Lilian Rice, a strong advocate for education. The ensemble of church-like buildings stretched the length of Paseo Delicias from Avenida de Acacias to La Granada. She was, among many roles, on the school board and directed their planning. Unfortunately only the north half of this rendering was

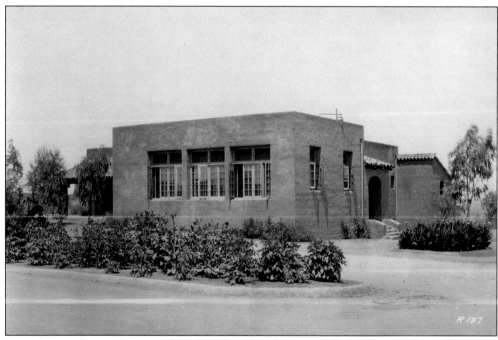

FIRST SCHOOL GROUP BUILDING. The first school building was modeled after a pueblo architectural style and was the least ornamental of Lilian's renderings. It housed a total of 10 students for all eight grades. The first graduate was Ivy Fidero in 1924. Even though the more monumental part of the school group was never built, the school grounds were used for outdoor recreation, pageantry, and events.

ever built. In the beginning, the school attempted to provide education for grades one through eight but later was reduced to grades one through six. When the children reached these grades, they were sent off the ranch to Oceanside or Escondido High School or the newly constructed San Dieguito High School in Encinitas, which Lilian Rice also designed.

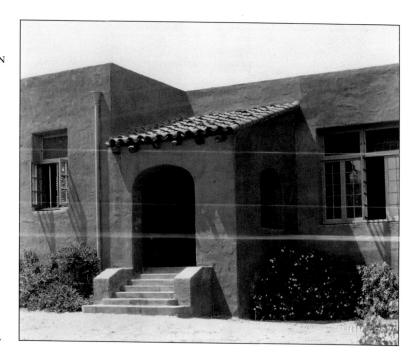

SCHOOL GROUP ON LA GRANADA. It wasn't until 1927 that the school was officially named the Rancho Santa Fe School, with its own district. The former name of the Aliso School, which predated Rancho Santa Fe, was retired. The new school consisted of the two buildings and a sizeable amount of land surrounding them.

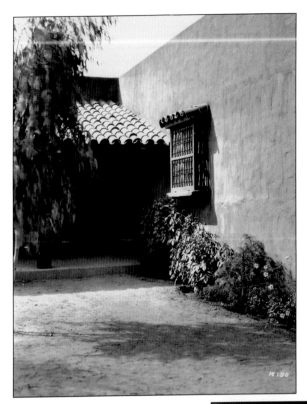

SCHOOL ENTRY ON LA GRANADA.
The Rancho Santa Fe School served the community well, however, by 1931 the ranch population had grown so quickly that a larger school was needed. It was constructed on Avenida de Acacias and was the school for the next two decades. That building is today the office of the Rancho Santa Fe Association.

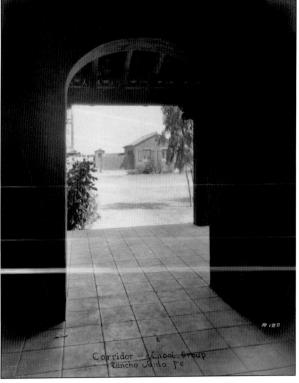

SCHOOL ARCH AND CORRIDOR.
Looking through the corridor from the school group, one can see the garage block buildings across Paseo Delicias. The well designed and constructed buildings offer an immediate patina of Old World. It is an amazing accomplishment executed by the best talent chosen by the Santa Fe.

IN TOWN RESIDENTIAL DESIGN. Lilian Rice's early designs may have been on spec for the Santa Fe. She might have made models for prospective buyers who wouldn't necessarily want to take on the responsibility of vast orchards. These homes would have been in the central area of the ranch. Parcels were deliberately made small around the village and then radiated out as large as 50 acres for intensive agriculture.

SPANISH VILLAGE RESIDENTIAL DESIGN. Spanish Village design was preferred by Lilian Rice in the beginning of her career. She once wrote, "With the thought early implanted in my mind that true beauty lies in simplicity rather than in ornateness." She adopted a restrained minimalism of proportion and scale, a rarity in architectural design at the time.

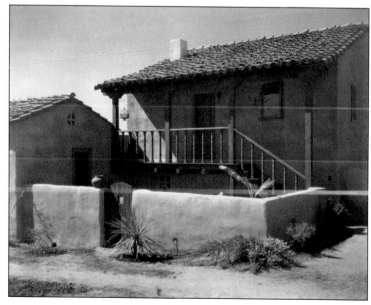

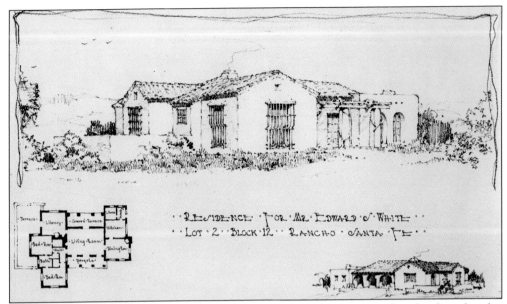

THE EDWARD S. WHITE HOUSE. Edward White was an early resident and orchardist who also served on the Rancho Santa Fe Fruit Association. Lilian Rice designed his home in an eclectic mix of cross gables, gable ends, and a bit of pueblo. This rendering is in her hand and can be detected by her printing, in particular her stylized letters *F*, *E*, and *S*.

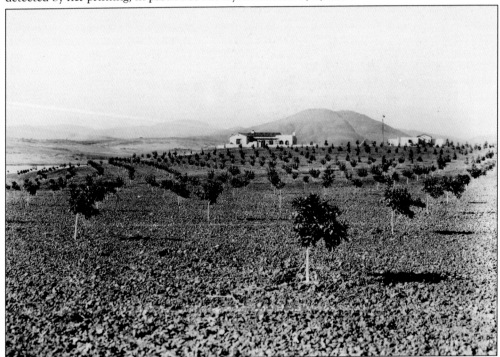

WHITE HOUSE COMPLETED. From drawing to reality, the Edward White house and orchards are in place. The projects undertaken by Lilian where going at a fast rate. She worked and lived on the ranch from 1922 to 1938 and provided designs for more than 50 homes, not counting the village core buildings.

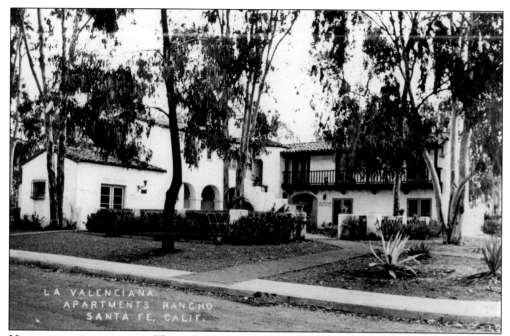

LA VALENCIANA
APARTMENTS RANCHO
SANTA FE, CALIF.

VALENCIANA APARTMENTS. The Valenciana Apartments were on the northeast corner of Paseo Delicias and La Granada. A long *L*-shape set back from Paseo Delicias afforded a courtyard and landscaping. Lilian's studio was on the lower floor under the Spanish balcony; she briefly lived above the store. Barton Millard, president of the Rancho Santa Fe Country Club, had his real estate office on the far left.

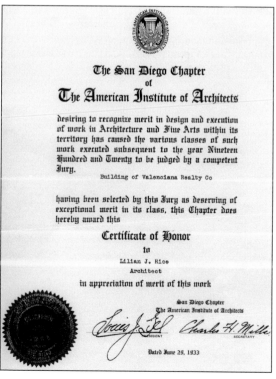

The San Diego Chapter
of
The American Institute of Architects

desiring to recognize merit in design and execution of work in Architecture and Fine Arts within its territory has caused the various classes of such work executed subsequent to the year Nineteen Hundred and Twenty to be judged by a competent Jury.

Building of Valenciana Realty Co

having been selected by this Jury as deserving of exceptional merit in its class, this Chapter does hereby award this

Certificate of Honor
to
Lilian J. Rice
Architect

in appreciation of merit of this work

San Diego Chapter
The American Institute of Architects

PRESIDENT SECRETARY

Dated June 29, 1933

AMERICAN INSTITUTE OF ARCHITECTS (AIA) AWARD, 1933. Lilian Rice was awarded a certificate of honor in architectural design for the Valenciana Apartments project by the San Diego chapter of the AIA. The project was also written up in national trade magazine, *Architect and Engineer*, prior to that. Lilian was clearly making her mark.

LILIAN RICE PHOTOGRAPHY IN SPAIN. After the construction of the first buildings in the village, the Santa Fe sent Lilian Rice to Latin countries such as Spain, Portugal, and Cuba. She did photographic reconnaissance of architecture and physical settings. It is interesting that her former boss and peer, Richard Requa, also traveled to the Mediterranean on a similar mission, although with a different sponsor. The difference in their portfolios speaks to how they both developed their personal styles. Requa's photographs focused on architectural details such as staircases, railings, windows, doors, and rooflines. Lilian's photographs were of tranquil scenes where architecture was a component of the setting. She innately observed the totality of the cultural environment.

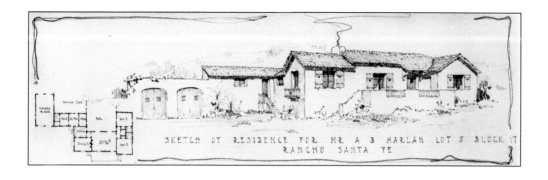

SKETCH OF RESIDENCE FOR MR A B HARLAN LOT 5 BLOCK 17
RANCHO SANTA FE

LILIAN RICE DESIGNS AND HER DRAFTSMEN. Now in private practice on the ranch, Lilian Rice took on residential work under her own name and architectural license. She built a home behind La Morada. She took on draftsmen who worked for Requa and Jackson. Two young men, Sam Hamill and Lloyd Ruocco, were also previous students of hers. They helped when she needed drawings for her clientele. These two drawings are not in Lilian's hand. Its not clear if either Hamill or Ruocco penned them, but the design is by Lilian herself. She encouraged both men to seek university training, which they did by attending UC Berkeley. She then hired two young draftswomen, Olive Chadeayne and Elinor Frasier, who remained with her until her death in 1938.

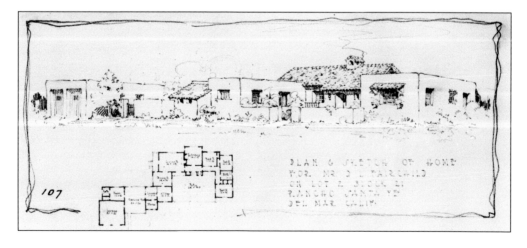

107

PLAN & SKETCH OF HOME
FOR MR D L FAIRCHILD
ON LOT 2 BLOCK 21
RANCHO SANTA FE
DEL MAR CALIF.

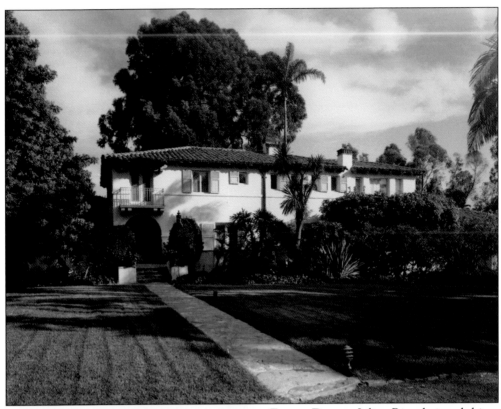

ESTATE DESIGN. Lilian Rice designed this home for the Binghams originally on 17 acres in 1930. After traveling to Spain, her design prowess was enhanced. Detailing, both exterior and interior, marks this home as one of her best estate designs. The Bingham House had the distinction of being the only house built on the ranch in 1935 due to the Depression.

BINGHAM HOUSE, DETAILS. Clientele with aspirations of ranch living and an appreciation of architecture began to arrive in the early 1930s. Lilian's attention to detail is evident in the Bingham House. An articulated arch and bracketed iron-rail balcony above are topped by an intricate eave and roof detail, which culminates the piece and shows a new complexity in her designs.

BINGHAM HOUSE, ARCHITECTURAL DETAILS. A necessary and functional element of roof drainage, a simple downspout, becomes a sophisticated design element crafted in copper and woven into the facade and eave with great technique and style. The Bingham House afforded Lilian the freedom to experiment and apply myriad details of the Old World.

THE SHAFFER HOUSE WINDOW DETAIL. Even in a simple design for this stylized iron-grilled window, everything was crafted specific to the needs of the subject home and client. Some of Lilian's designs were more elaborate than others, while some were more minimal. Her designs were always a collaboration and with great deference to the wishes of her clientele.

FRANCISCO BUILDING EAVE DETAIL. The Francisco Building would have been designed under the aegis of the Santa Fe architect of record, Requa and Jackson, even though Lilian was always the project person in a supervisor role. The Francisco Building was connected by a long arched corridor to the Santa Fe Land Improvement Company office.

FRANCISCO BUILDING PARAPET DETAIL. The exterior detailing represents many of the Spanish and Mexican Colonial Revival cues, such as this muted quatrefoil design incorporated into the parapet over the front entry. In the above photograph, a line of coved dentils under the cornice repeat in the shadows. The Francisco Building housed the first grocery store in the village, later taken over by Ashley's Market.

The ENDLESS MIRACLE OF CALIFORNIA

THE ENDLESS MIRACLE. A Santa Fe publication, *the Endless Miracle*, was known for its excesses in extolling the virtues of Rancho Santa Fe. However, for a publication from the 1920s with excellent graphic qualities, it makes an important artifact reflecting the history of Rancho Santa Fe. It was not unusual for railroad departments to issue brochures casting positive imagery of the West. The motivation was to quell the fears of easterners who had only heard of the lawlessness of the Gold Rush years and the mythology of red-faced savages. Leone Sinnard had been recruited by the Santa Fe for his former work at the Southern Pacific Railroad in San Francisco. His primary job at the time was in the colonization department, which published these types of brochures.

VIEW OF THE VALENCIANA APARTMENTS. From the Joers-Ketchum doorway at the intersection of Paseo Delicias and La Granada is a view of the Valenciana Apartments. Real estate agent and first president of the Rancho Santa Fe Country Club Barton Millard had his office to the left of these units, which were less apartments than business offices. The architectural studio of Lilian Rice was on the lower level under the long Spanish wood balcony. Her first living space was above her studio. She later moved to a home she built behind La Morada. In this view, one can see the separated paseo with an unimproved median awaiting landscaping. All the architecture within this framed composition on both sides of Paseo Delicias was designed by Lilian Rice.

84

Six

THE PEOPLE OF RANCHO SANTA FE

*It is an old ranch with a romantic past, yet a new ranch with all
the promising appeal of modern country living.*

—Ruth Nelson, *Rancho Santa Fe: Yesterday and Today*, 1965

The people in Ranch Santa Fe's history represent a broad range of special personalities. First there were the visionaries and the placemakers: Walter E. Hodges, vice president of Santa Fe; E. P. Ripley, president of Santa Fe; Col. Ed Fletcher, local development entrepreneur; Leone G. Sinnard, ranch engineer; Lilian J. Rice, ranch architect; A. R. Sprague, agronomist; Glenn A. Moore, landscape architect; and the entire Santa Fe Land Improvement Company team, et al. Without the foresight of these professionals and immense resources of the Santa Fe Railway, the area would have been developed much differently.

Then there were those who managed and helped shape the ranch in the post–Santa Fe period: Sydney and Ruth Nelson, the Clotfelters, the Millards, the Badgers, the Macdonalds, the Boettigers, the Vorises's, the Ashleys, and the list goes on. These were the first residents who believed in the dream of Rancho Santa Fe and populated the community and laid down its first social values.

Finally, those who grew up in this special community—the children. Their memories are of the "good old days" when one could play with imagination and explore the unspoiled country surrounding. They rode horses to school, fished in the rivers and lakes, played in the fields, took trips to the beach, and attended year after year of school with the same few friends.

Since those halcyon days from the 1920s through the 1960s, the ranch has grown into an extraordinary residential community unlike anything on the West Coast.

It would be impossible to include all the people who have been involved in the making of Rancho Santa Fe. It is truly a distinct place of great character, and not by mistake, but from excellence in town planning with a healthy respect for its previous culture and the land on which it sits.

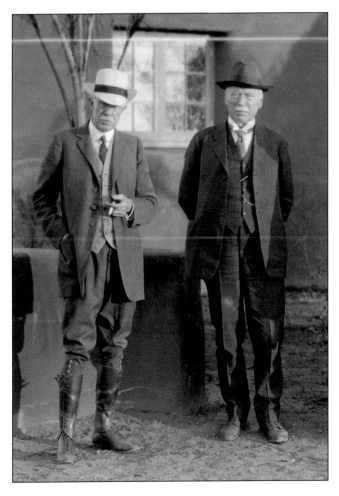

THE SANTA FE MEN. Pictured here are Walter E. Hodges (left), vice president of the Santa Fe Railway, and E. P. Ripley, the president. Ripley was visiting from the Chicago office to review the progress of Hodges and his team. Local developer Col. Ed Fletcher had the greatest respect for Ripley. Fletcher's memoirs couldn't lavish enough praise, calling him "an empire builder."

COL. ED FLETCHER, ENTREPRENEUR. Ed Fletcher is one of the most significant people in San Diego County history, as a land and water developer. He worked closely with Walter Hodges on Hodges Dam, Lake Hodges, and related water districts. He was given full credit for his persistence and ultimate success at Rancho Santa Fe. Fletcher remained involved in Rancho Santa Fe as a sales agent and as an association board director.

Leone G. Sinnard, Ranch Engineer, and Lilian J. Rice, Ranch Architect. The two people who deserve the most credit for the character of Rancho Santa Fe are Leone G. Sinnard and Lilian J. Rice. Both were talented and dedicated professionals in their respective fields. Sinnard was a consummate land engineer with a healthy respect for the natural features of the ranch. Lilian Rice had university training and possessed an innate talent. Her affinity for her native land helped to develop a hybrid style of Spanish Revival architecture that appeared as though it indeed came from the land. The two worked together brilliantly from 1922 to 1927. Lilian maintained a deep regard for Sinnard, even including him in her will, although she predeceased him.

DOUGLAS FAIRBANKS SR. AND MARY PICKFORD. The two are shown at left on a visit from Hollywood with fellow actor Lillian Gish (right). In 1926, Fairbanks purchased 3,000 acres of land southeast of the San Dieguito River from the Santa Fe and named it "Rancho Zorro." Essentially Fairbanks bought one third of the old rancho. With ranch manager William Smart, he built a dam and lake, a pump house, a manager's residence, and planted the majority of his acreage in Valencia oranges that were propagated in the Fairbanks nursery. Rancho Zorro was named after one of his most famous movies, *Mark of the Zorro*, filmed nearby at Mission San Luis Rey. Prior to their divorce in 1935, in happier times, Mary and Douglas etched their names on the top of the Fairbanks dam.

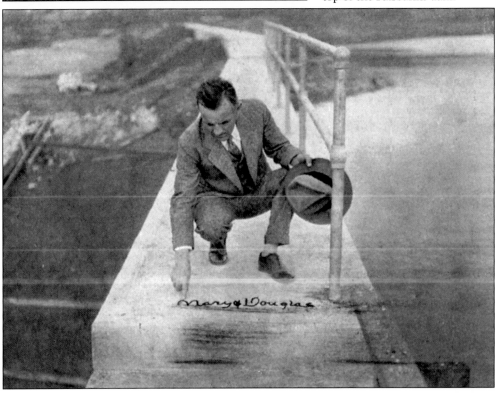

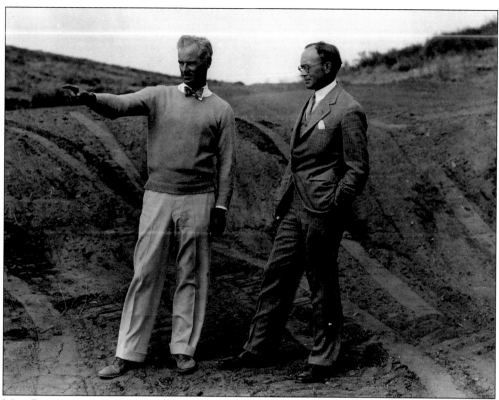

MAX BEHR AND BARTON MILLARD. Max Behr, the ranch's golf course architect, points out the natural flow of the course to Barton Millard, president of the Rancho Santa Fe Country Club. Behr was known for working with the natural golf terrain. He believed that playing golf should be a "delightful expression of freedom." Millard provided strong leadership as the club's president.

GLENN A. MOORE, RANCH LANDSCAPE ARCHITECT. A self-taught landscape designer, Moore came up through the nursery trade. He provided landscape consultation to the Santa Fe and to residents from 1923 to 1946. He also operated the ranch's first nursery in the heart of the village. Moore wrote in *Rancho Santa Fe Progress* magazine, "Life would be flat indeed without color, or order, or the pageantry that nature gives to the somber earth."

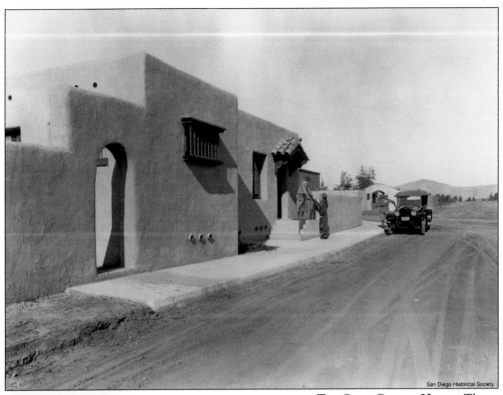

THE CIVIC CENTER HOUSE. The Civic Center House was the first permanent residence built in Rancho Santa Fe in 1923 and was designed by Lilian Rice, shown above on the staircase landing. It housed several families as somewhat temporary quarters until their homes were built. The first occupants were ranch manager Sydney R. Nelson, his wife, Ruth, and son Bob, who lived there until 1926. The second family was the Macdonalds. Pictured at left is Marion Macdonald, wife of Ranald Macdonald, the first president of the Rancho Santa Fe Association, their son Don, and dog Buster. Today it is called La Flecha House and is the home of the Rancho Santa Fe Historical Society.

WILLIAM AND
BEATRICE BOETTIGER.
William O. Boettiger
was the manager for
the Santa Fe Irrigation
District. Here he is
with his wife in front
of their home on
La Crescenta (the
Crescent) in 1930.
Boettiger not only
managed water for
all ranch residents
and orchardists, but
he also managed
water throughout the
district boundary,
which covered Solana
Beach and beyond.

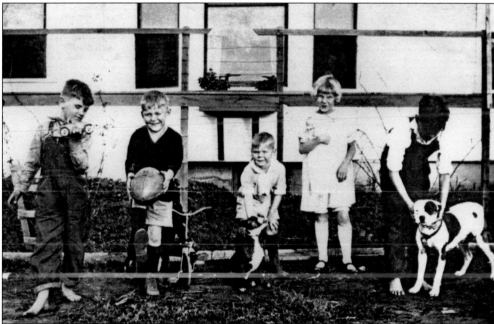

THE BOETTIGER CHILDREN. Bill (right), Claire (second to right), and Bud (center) Boettiger are
shown here with their cousins on Christmas in 1926. Growing up on the ranch was the great
fortune of all the children of the Santa Fe team members and residents. It was a simple and
unspoiled life with poignant memories of friends, classmates, nature, and pets.

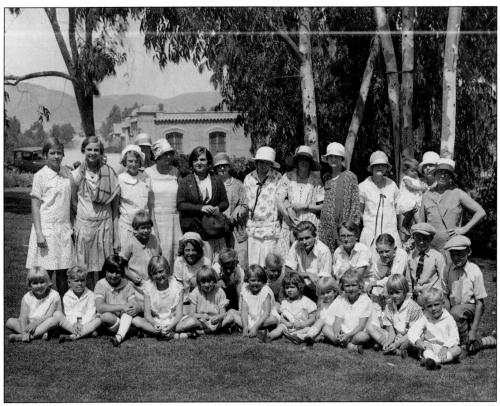

A PTA PARTY IN 1929. Standing are, from left to right, Helen Sprague, Virginia Voris, Beulah Attrill, unidentified, Martha Voris, Ruth R. Nelson, four unidentified, Edith Megrew, and Mrs. Attrill. The only people identified sitting and kneeling are Bobby McKenna, Dorothy McKenna, Mary Megrew, Charles Nelson, John Megrew, Paul Sprague, and John Sprague.

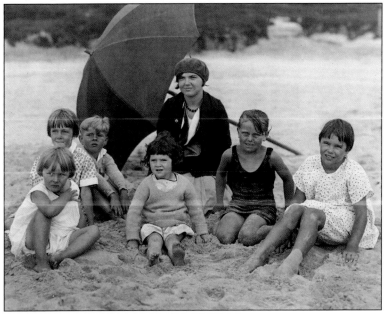

A DAY AT THE DEL MAR BEACH. Caring for the children is Martha Voris; second from the left is Barbara Sprague; and at the far right is Mary Megrew. Going to Del Mar Beach was a special trip for the schoolchildren. The Rancho Santa Fe Association owned a small parcel of land at Del Mar Beach for its residents.

PLAYING AT THE BEACH. Pictured here are Nathalie Millard (catcher), daughter of Barton Millard, the president of the Rancho Santa Fe Association, and Virginia Voris (batter), daughter of U. L. Voris orchard development contractor. Ranch dwellers often went to Del Mar Beach. The old Del Mar Pier is behind the girls as they play beach baseball.

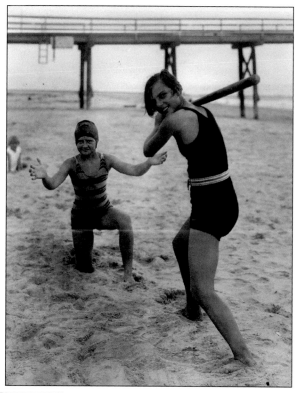

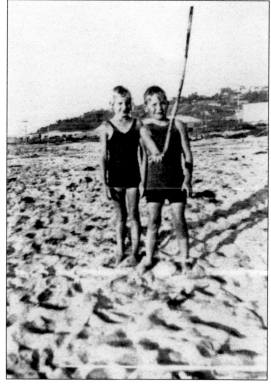

BOETTIGER CHILDREN AT THE BEACH. Bill and Claire Boettiger played on long summer days at Del Mar Beach. Ranch residents spent countless hours and days swimming, picnicking, and playing in the sand. From the ranch to Del Mar it was only a short drive down Via de la Valle (Way of the Valley).

CONNIE CLOTFELTER SHOPPING AT ASHLEY'S. Originally Francisco's Market was the first in the village, and Fred Ashley used to be a delivery person in the area. When Francisco's closed, Fred reopened it as Ashley's Market. Pictured at left is Connie Clotfelter with Fred Ashley carrying her groceries to her car, a very familiar sight. (Courtesy of the Ashley Family Collection.)

FRED AND MAXINE ASHLEY. Fred and Maxine, two high school sweethearts in 1928, are seated on the running board of his car. They would marry soon after and start a family. Maxine operated the Rancho Santa Fe Golf Course concession and was quite an accomplished golfer herself. (Courtesy of the Ashley Family Collection.)

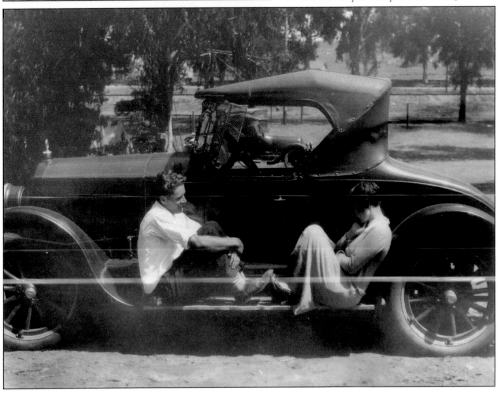

GARDEN CLUB GIRLS. The Rancho Santa Fe Garden Club, founded in 1929, was one of the most popular garden organizations in San Diego County. Pictured from left to right are the daughters of garden club members Jane Wood, Jean Smart, Patty Welden, Peggy Miller, and Charlotte Wood. At a Mayday Blossom Exhibition, the girls presented corsages to their mothers. (Courtesy Rancho Santa Fe Garden Club.)

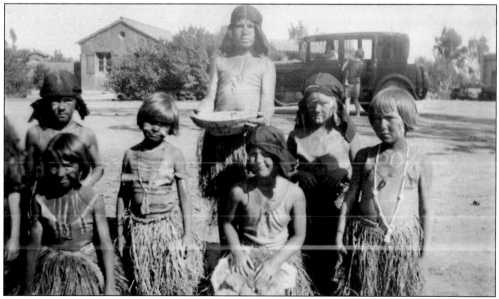

SCHOOLCHILDREN IN A NATIVE AMERICAN PAGEANT. At the close of the school year a pageant was usual fare. In 1930, a play in which the younger children played the Native Americans and the upper grades were the Spaniards was performed. The story line was essentially about the simple life of the Indians and the arrival of the Spaniards.

REG CLOTFELTER. Reg Clotfelter began his career as the manager of the La Morada Hotel, which became The Inn at Rancho Santa Fe. He was instrumental in guiding a sensitive expansion of the hotel in the 1940s. The cottages that now grace the grounds of The Inn are part of his legacy. His wife, Constance (or "Connie"), was a much-beloved resident who was deeply involved in her community and wrote *Echoes of Rancho Santa Fe.* Reg founded Clotfelter Real Estate in 1931, which has continued through generations of Clotfelters. He was the longest-serving director on the Rancho Santa Fe Association Board and also served on the San Diego County Planning Commission. Below is Reg's annual offering to the community, the Rancho Santa Fe Country Homes Directory, better known as the "telephone card."

RANCHO SANTA FE JUNE • 1941 COUNTRY HOMES

Avery, Paul H., Lndscpe. Archt....3611	Kerguelen, Eugene de.........3391	Meyer, Charles F..............2961
Avery, Edith Mrs.............3612	Lancaster, John A.............3331	Millor, Russell H...............2401
	Lewis, Major Nerd O..........2711	Millard, Barton................2781
Badger, R. E., Agricultural Contr...2881	Lineaweaver, Charles P........2351	Millard, Barton, r.............2021
Badger, R. E., r..............2051	Locke, George D..............3101	Millard, H. Ray................3601
Badger, Mrs. Louise, Fountain	Lochhead, John T.............2601	Moore, Glenn A...............2191
Lunch3831	Lyle, Hilliard G...............3152	Morrill, Dr. Gordon N.........3401
Bakewell, Maitland2821		Morris, R. M..................3711
Ballard, V. V., r.............3311	MacDonald, Ronald2761	
Ballard, Volant V., orchardist...2261	Mann, R. B..................3021	Nelson, S. R..................2671
Bechberger, W. A............2011	Marshall, George P...........3091	Norton, Porter F..............3201
Benbough, Legler2941		Novak, John E., M.D..........3211
Bertschinger, Dr. Carl.........2461		
Betts, Chas. E................3521	SALES	O'Hern, Jas. R................2366
Bingham, S. H................2891	OFFICE	Peck, George N...............2211
Brenner, G. J................2701	RANCHO SANTA FE	Pelko, Albin, Deputy Sheriff.....3411
Bristol, C. H..............2331		Porter, Harry L................2111
Burnaby, Frank8061		
Burnham, John3301	R. M. CLOTFELTER	Quigley, Wm. A...............3561
		Rancho Del Mar...............3121
Cameron, Dr. Andrew C........2446	PHONE	Rancho Santa Fe Golf Course.....3011
Carmichael, Norman3111	R. S. F. 2611	Rancho Santa Fe Inn...........2531
Carothers, T. L...............2431		Rancho Santa Fe Sales Office,
Claggett, Mrs. Belle...........2581		R. M. Clotfelter...........2611
Clotfelter, R. M., Rancho Santa Fe	AGENT	Rancho Santa Fe Store.........3281
Sales Office2611	GENERAL INSURANCE	If busy call................3291
Clotfelter, R. M., r...........2612	*Insurance Company*	Rancho Zorra2471
Copeland, R. H...............3751	*of North America*	Reed, J. T...................3581
County Road Station3771		Richardson, George2311
Crawley's Miss School2421		Robertson, John S.............3031
Curtis, Clinton J..............2321		
		S. D. City of—Hodges Dam......3161
Darling, Wm. S...............3691		—San Dieguito Dam..2441
Darrough, Glen3771		San Dieguito Stables2381
Dormer, Jack3621		Santa Fe Irrigation District—
Douglas, Kingman2041		Office2651
Davis, Eunice3911		Selby, Peter2661
Durant, Mrs. Walter L.........3181		Sherman, John B..............3661
		Skow, Al2282
Fairbanks, Douglas Ranch2471	Massie, W. B., El Ranchito.....2731	Sprague, Dairy ...Del Mar 8702-J-3
Francisco, R. C...............3381	McGowan, Lewis A...........3631	Smart, Wm. A................2251
	McVay, John H..............2551	Smillie, James C...............2511
General Petroleum Service Station..2131	Megrew, George3191	
Gibson, James A..............2691		Tanner, Clifford G., r.........3971
Gilbert, Mrs. A. W............2591		Tanner Nurseries2341
Gildersleeve, Miss Virginia C.....2561		Townley, Morris3131
Good, George3456		Tunney, W. F.................2521
Guldahl, Ralph2931		
		Van Linge, Thomas............2391
Harris, G. S..................2286		
Hart, Mrs. F. N...............2091		Wallace, Louis R..............3241
Henry, J. Bayard.............3106		Ward, C. M..................2951
Hennig, Robert2801		Watson, Starling, Archt.........2641
Hoover, Roscoe2926		Weldin, G. C., Lt. Comdr., U.S.N..2361
		Wells, Albert B................3701
Inn, The, at Rancho Santa Fe.....2531		Garage Private3156
		Whittaker, C. K...............3901
Joers, Fred W................2901		Wick, Arthur L................2081
Jacobs, Miss Mildred..........3551		Willoughby, Dave, Riding Stables..2936
Janinet, Leon P...............2851		Wilson, Misses F. E. and A. L....2441
Jones, Lowell E...............3271		

CALL THE OPERATOR IN CASE OF FIRE—ACCIDENT or the SHERIFF

JOHN AND JOSEPHINE ROBERTSON. Hollywood film director John Robertson enjoys afternoon tea with his wife, Josephine, at their hilltop home located on El Camino del Norte (Road of the North). Josephine was very active in the garden club and also directed the popular plays known as *The Strollers of Rancho Santa Fe*. John was the founder the Rancho Santa Fe Riding Club.

JOAN OTTEN RIDING REX II. In this 1947 photograph, Joan Otten rides Rex II as they easily clear the picket fence in preparation for the open jumping class of the first annual horse show and polo matches on the club field. The Rancho Santa Fe Riding Club was located on Rambla de las Flores.

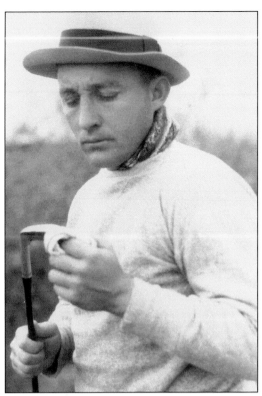

BING CROSBY POLISHING HIS GOLF CLUB. In 1934, Bing Crosby, Douglas Fairbanks Jr., Pat O'Brien, and others helped open the Del Mar Race Track. Besides horses, he loved golf and the Rancho Santa Fe course. His popularity and enthusiasm for golf and horses brought many to visit who eventually made Rancho Santa Fe their home.

PUTTING AT THE CARMICHAELS. Once the golf course was completed, many enthusiasts moved to Rancho Santa Fe. The course was designed to challenge the best, yet it was kind to the novices. There were 20 sand traps, and every hole was unique. Norman Carmichael, an avid golfer, entertains friends with a practice putting green outside his home on La Valle Plateada (Silvered Valley).

AIRCRAFT SPOTTING DURING WORLD WAR II. Being on a high point in Rancho Santa Fe, the Robertsons allowed the military and volunteers to be lookouts for enemy aircraft during World War II. Several of the ranch's young men learned to identify aircraft, foreign and domestic, during this process.

THE GRAY LADIES. Several Rancho Santa Fe women volunteered their services during World War II in the Red Cross unit called the Gray Ladies. They provided recreational and comforting services to the injured. The John Burnham house was converted into an official U.S. Naval Hospital rehabilitation facility that attended to as many as 40 patients at a time.

The Nelsons at Their Row House. Not enough can be said about the contributions of Sydney and Ruth Nelson. Sydney became the ranch manager after the Santa Fe period. He was not just a manager but an advocate for the true character of the ranch. Ruth Nelson was responsible for keeping the values of tradition and history alive. Her writings, archival collections, and participation in cultural events set the highest standard of appreciation for Rancho Santa Fe and its cultural origins.

Class of 1948–1949. Teachers Mrs. Trethaway (left) and Ellen Ross (right) flank the Rancho Santa Fe School class picture. Pictured from left to right are (first row) all are unidentified with the exception of Penny Brook in the middle holding the class sign; (second row), two unidentified, Marguerite Langenskold, Susan Clotfelter, Vickie Miller, unidentified, Kim Gordon, two sisters of ranch employees, and unidentified; (third row) Richard Clotfelter, three unidentified, Elaine Palmer, Brenda Wheeler, unidentified, and Leo Sides; (fourth row) Alfred Hill, Christopher Renn, Robert Redaeker, Bob Francisco, Michael Tucker, Dick Hillman, Danny Mason, and two unidentified.

RANCHO SANTA FE HISTORICAL SOCIETY BOOK COMMITTEE. In 1991, the historical society took on a noble cause and surveyed the historical resources of the ranch. The effort resulted in several Lilian Rice buildings being listed on the National Register of Historic Places. The Historic American Building Survey (HABS) measured drawings that were made of the village buildings, and a book memorializing the project was published, entitled *Rancho Santa Fe: A California Village.* Those involved were, from left to right (standing) Keith Behner, Sandy Somerville, John White, and architect John Henderson; (seated) Meriam Ames, Pat Cologne, Roxana Phillips, Carol Bowers, Phyllis Paul, and Florence Raft. The HABS team, seen below, included supervisor John White, Juan Tampe, Sheri Bonstelle, Lauren Farber, E. Matthew Walter, and Piotr Trebacz.

Rancho Santa Fe
Progress

VOL. 2 SEPTEMBER 1928 NO. 3

RANCHO SANTA FE PROGRESS MAGAZINE. As a follow up to the Santa Fe magazine *The Endless Miracle*, a marketing tool, the Santa Fe began a new magazine *Rancho Santa Fe Progress*, which documented the progress of the ranch in glowing terms. Published monthly, the covers often resembled that of the early *Sunset Magazine* with breathtaking photography. Inside were articles written by presidents, managers, and chairs of organizations that read like a who's who of the ranch. Information on water, orchards, architecture, landscaping, and society was followed with a keen eye and great pride. *Rancho Santa Fe Progress* was unfortunately only published for three years, but is an authoritative reference to the history and the making of Rancho Santa Fe.

Seven
THE PROTECTIVE COVENANT

To perpetuate the reign of beauty at Rancho Santa Fe and to guard investment . . .

—Rancho Santa Fe Protective Covenant

The Santa Fe stewarded the development of Rancho Santa Fe. It was committed to controlling the visual and productive character of the ranch, which involved "highly desirable restrictions to protect investment." Deed restrictions were put in place for a period of 10 years with the expectation that the Santa Fe's interests would then "sunset."

Sinnard had taken ill in early 1927 and left the project. Sydney Nelson, his able assistant, took over as general manager. By 1928, eighty percent of the property had conveyed to individual owners. The Santa Fe, wanting to protect the project into the future, engaged town planner Charles H. Cheney to form an association that would accept all responsibility for the ranch and continue to impose restrictions. Written into the code was the creation of the Rancho Santa Fe Association and the Art Jury. The Rancho Santa Fe Protective Covenant was adopted in February of 1928. Barton Millard was the first president of the Rancho Santa Fe Association, and Lilian Rice chaired the Art Jury.

During the post–Santa Fe period, the Association added significant projects: the Rancho Santa Fe Country Club and Golf Course and adjacent golf course estates; the Rancho Santa Fe Riding Club, founded by Hollywood director John Robertson; and the expansion of La Morada. All were sophisticated amenities intended for a gentrified lifestyle.

In the late 1930s, famous actor, crooner, and ranch resident Bing Crosby informally staged golf tournaments called "clambakes" at the end of each Del Mar racing season. The Depression had taken its toll on the Rancho Santa Fe Protective Covenant, which was still in its infancy. His informal gatherings evolved into the Bing Crosby Pro-Am Tournaments from 1937 through 1942, saving the golf course from extinction.

Rancho Santa Fe continued to grow, albeit slowly. Two significant events affected the pace greatly: the Great Depression and World War II. However, as intended, the ranch not only survived but flourished.

RANCHO SANTA FE COUNTRY CLUB BROCHURE. During the Depression the club experienced financial hardship. In 1932, the Rancho Santa Fe Country Club opened its doors to public play. Still feeling the financial pressure in 1934, the club board transferred the title of its property and possessions to the Rancho Santa Fe Association.

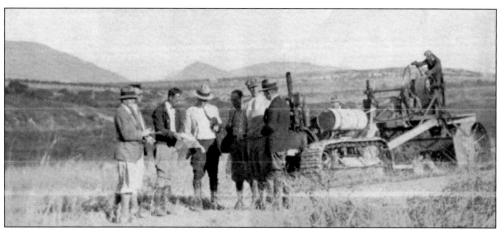

GOLF COURSE CONSTRUCTION TEAM. This construction was reported on in a December 1927 article of *Progress* magazine called "Planning a Golf Course That Challenges Skill," by Max Behr. A photograph of the team was included. Breaking ground are, from left to right, Edward S. White, Ranald Macdonald, Barton Millard, D. M. Richards, Briggs C. Keck, Max Behr, and Sidney R. Nelson.

EARLY GOLF COURSE GRADING. Max Behr, the course architect, working with gentle terrain and simple mechanical and financial resources, devoted his time to this 18-hole course, intent on making it one of the most strategic on the Pacific Coast. Leveling of the course was done primarily with horse-drawn scrapers and drags. Tractors with 60 horsepower were used to model the fairways.

COMPLETED GOLF COURSE. Construction started in December 1927, and by June 5, 1929, the course was complete and open for play. The first group to tee off was president of the golf club Barton Millard, Hollywood director Ted Reed, and golf professional Willie Hunter. Today the course is considered one of the finest in California.

In Temporary CLUB QUARTERS

Rancho Santa Fe Golf Layout
Now Complete

With its clubmaker's shop and temporary clubhouse quarters practically finished and its fairways thriving under the combined potency of Rancho Santa Fe sunshine and an effulgent quota of water, the Rancho Santa Fe Country Club is now functioning in an orderly and auspicious manner. The new structure, the particular pride of President Barton Millard, will be ready for use on or before August 1st. It is set snugly on the edge of the barranca below the site of the main clubhouse-to-be and looks directly down on the first tee, which is reached by a rustic bridge.

At one end is a clubmaker's shop, 15x30 feet in size, with a tier of racks for clubs, buffer and other facilities for the clubmaker.

Along the center of the building is the golf shop and grill. A combination refrigerator and counter extends across one end. Here sandwiches and cold drinks will be served. Golf balls and other necessities of the royal and ancient game will be found on sale here. This room is 16x28 feet in size and in one corner is an attractive fireplace. It connects up with the main locker room where twenty-five lockers are to be installed for the use of out-of-town players and where the men's showers are found.

The grill also opens onto a long terrace, 16x44 feet in size, where bridge tables are to be placed for social diversion and for dining purposes.

A ladies dressing room and a long distance telephone booth complete the list of the club's facilities. The shop is indeed a very attractive and useable building, one that should suffice for all the needs of the club for sometime to come.

SCORE CARD

Hole	Out Yards	Par	Ladies' Par	Handicap
1	407	4	5	13
2	415	4	5	3
3	160	3	3	17
4	585	5	6	5
5	437	4	5	9
6	390	4	5	11
7	93	3	3	15
8	455	5	5	1
9	365	4	4	7
Out	3307	36	41	

Hole	In Yards	Par	Ladies' Par	Handicap
10	311	4	4	12
11	435	4	5	2
12	437	4	5	8
13	390	4	5	4
14	185	3	3	16
15	400	4	5	14
16	393	4	5	6
17	166	3	3	18
18	511	5	6	10
In	3228	35	41	
Out	3307	36	41	
Total	6535	71	82	

OTHER PHYSICAL FACTS

Championship length, 6792 yards.

Automatic snap-valve sprinkling system over the entire course, with 1157 outlets, irrigating 120 acres of fairway.

Course built by Max Behr at a cost of approximately $220,000.

Nearly thirteen miles of pipe, ranging in size from 12-inch to 1¼-inch mains.

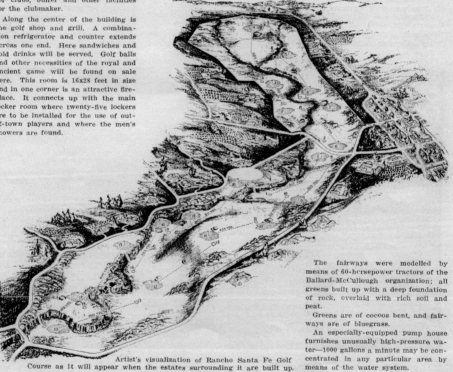

The fairways were modelled by means of 60-horsepower tractors of the Ballard-McCullough organization; all greens built up with a deep foundation of rock, overlaid with rich soil and peat.

Greens are of cocoos bent, and fairways are of bluegrass.

An especially-equipped pump house furnishes unusually high-pressure water—1000 gallons a minute may be concentrated in any particular area by means of the water system.

Artist's visualization of Rancho Santa Fe Golf Course as it will appear when the estates surrounding it are built up.

GOLF COURSE LAYOUT AND SPECIFICATIONS. The perspective rendering of Max Behr's final golf course design was published in a 1929 issue of *Rancho Santa Fe Progress* magazine. During construction, changes were made to take advantage of the natural contours of the land. The final course measured 6,792 yards with a par of 72. The following quote from the *Progress* article illuminates the enthusiasm the community had for their new golf course, "Its fairways thriving under the combined potency of Rancho Santa Fe sunshine and an effulgent quota of water, the Club is now functioning in an orderly and auspicious manner."

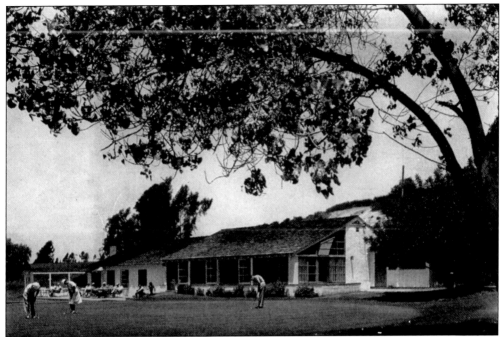

ORIGINAL GOLF CLUBHOUSE. Charming and cozy, a quaint facility built in 1929, the golf shop and caddy house served as the clubhouse for the Rancho Santa Fe Country Club until it was torn down in 1984. From the grill, diners enjoyed watching fellow golfers practicing their putts on the green in front.

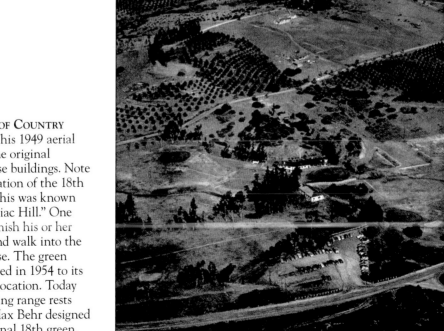

AERIAL OF COUNTRY CLUB. This 1949 aerial shows the original clubhouse buildings. Note the elevation of the 18th green. This was known as "Cardiac Hill." One would finish his or her round and walk into the clubhouse. The green was moved in 1954 to its present location. Today the driving range rests where Max Behr designed the original 18th green.

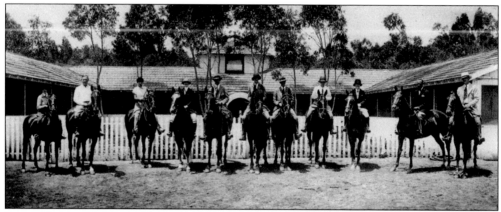

LINED UP AT THE LOOMIS STABLES. Equestrians are lined up in front of the Loomis Stables in the clearing of a 2,000-acre eucalyptus grove at Osuna 1. Pictured in the group are Mr. and Mrs. Ralph Claggett, Montague Ward, Mary Josephine Bishop, A. W. Gilbert, Mr. and Mrs. R. B. Mann, Glen Tomlinson, and Miss Stevens.

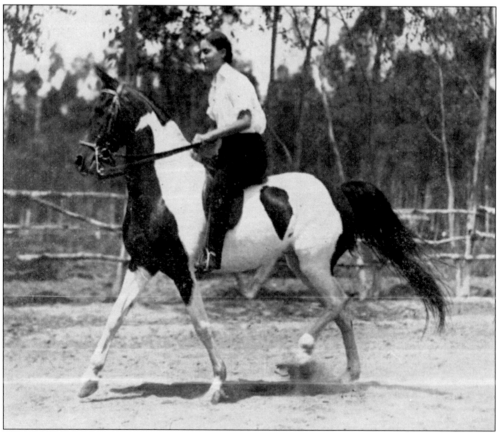

PEGGY LOOMIS ON LITTLE EVA. "It's great riding country," says Norbet Nettleship, editor of *Sportolouge*, the horse authority of the West. The weather is ideal for the horses. Peggy Loomis is seen here with her five-gated saddle pony, Little Eva. They were a familiar sight on the Ranch bridal paths.

LOOMIS STABLES. Owned by Mr. and Mrs. Arthur K. Loomis of Pasadena, and one of only two stables on the ranch at the time, the Loomis Stables was located on the ancestral grounds of Osuna 1. It was a breeding stable for fine saddle horses. By 1929, Loomis had 45 acres and 17 horses on the property.

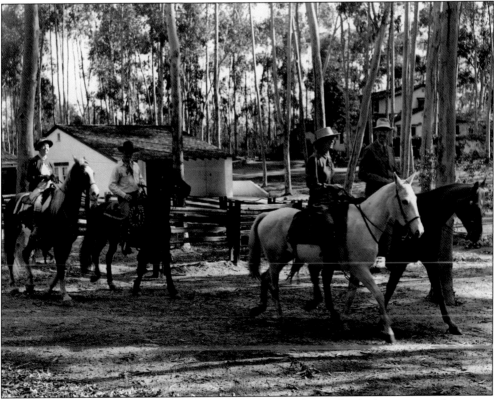

THE WILLOUGHBY STABLE RIDERS. Rancho Santa Fe was a haven for the horsey set with its great open spaces and many miles of countryside. The extensive trail system included bridal paths leading through eucalyptus groves, mature orchards, picturesque mesas, and past beautiful homes to the lakes, mountains, and the ocean.

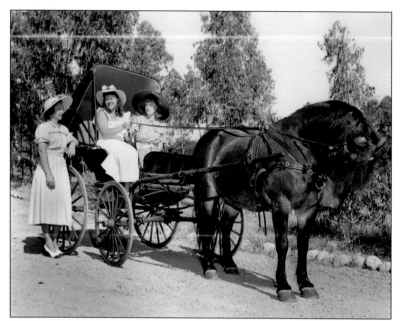

HORSE-AND-BUGGY PUBLICITY PHOTOGRAPH. A perfectly staged photograph for an upcoming horse show has the ladies dressed up in their finest. Standing is Mildred Anne Morrow Renn, holding the reins is Mrs. Lester (Carol) Wall, and next to her is Mrs. Carl (Sandy) Schlaet.

POLO MATCHES. On March 12, 1946, the Rancho Santa Fe Riding Club acquired property from the irrigation district. Members worked hard to clear the land and make it suitable for riding. Under the supervision of Guy Campbell, a polo field was built. In October 1947, the first polo matches and horse show were held at the riding club. Later in the century, Prince Charles of Wales was part of the site selection committee that chose the Rancho Santa Fe Riding Club as host of the polo events for the 1984 Summer Olympics.

RANCHO SANTA FE PROGRESS

VOL. III JUNE 1929 NO. 2

EQUESTRIAN COVER OF PROGRESS. The spirit of Rancho Santa Fe is truly presented on this cover. The ranch was becoming a significant equestrian community. There were two stables, the Claggett and Loomis Stables. Marketing brochures would reach out to the equestrian enthusiasts, encouraging them to visit the area. Those who stayed at La Morada could rent horses from either stable and ride along the miles of scenic bridal paths and into the wide-open country surrounding the ranch. Horses were a big attraction in the region, which also coincided with the development of the Del Mar Race Track.

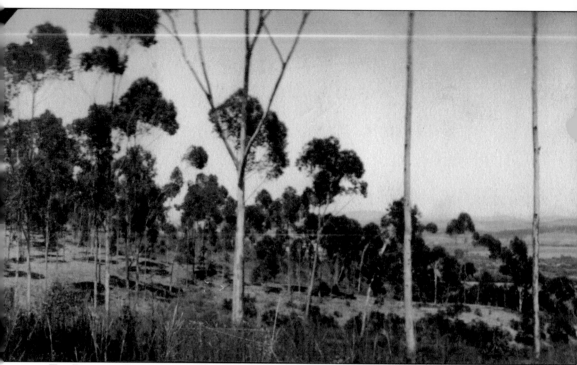

THE PASTORAL LANDSCAPE OF RANCHO SANTA FE. This photograph could be mistaken for an early-20th-century California Plein Air painting. The tall, slender trunks of the eucalyptus trees create a vertical pattern along the landscape, most effectively captured by an unknown photographer. The image gives a clear picture of the topography, vegetation, and sky, all in a sweeping vista.

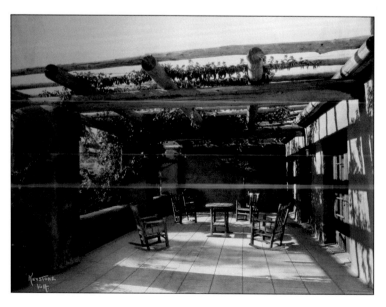

LA MORADA RUSTIC PATIO. Outdoor design received as much attention as indoor. This carefully composed photograph essentially shows an outdoor room that evokes the simple beauty of Rancho Santa Fe. These images became models for a Southern California rural, yet urbane, lifestyle. (Courtesy Rancho Santa Fe Garden Club.)

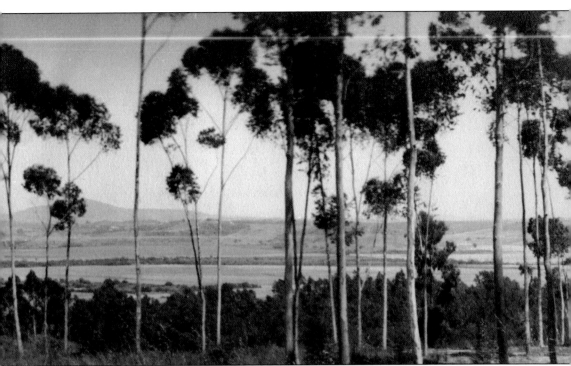

Open spaces and distant views were a significant feature of the character of early Rancho Santa Fe. The genus eucalyptus is not native to the North American continent, but it has acculturated over time and can be considered a metaphor for the people of California, albeit in horticultural terms. (Courtesy Rancho Santa Fe Garden Club.)

FRONT OF OSUNA 1 WITH RUSTIC PATIO. In the mid-1920s, as part of the Barlow restoration of Osuna 1, rustic patios brought living space out of doors. This simple home, dating back well before California statehood, set the tone for the design values realized at Rancho Santa Fe. (Courtesy Rancho Santa Fe Garden Club.)

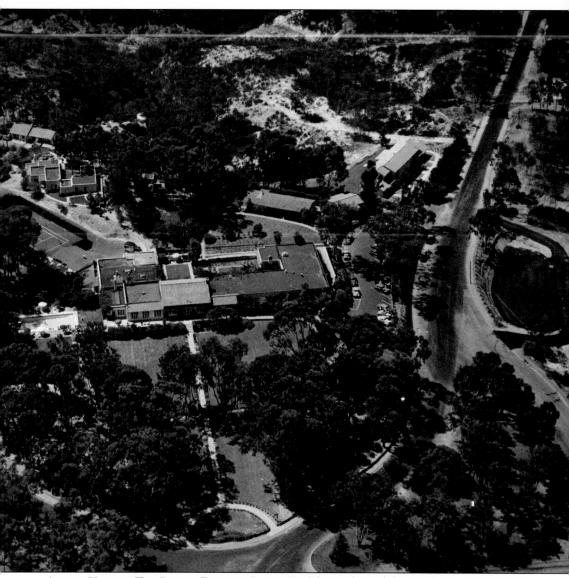

AERIAL VIEW OF THE INN AT RANCHO SANTA FE. The nucleus of the ranch was, and remains, the former La Morada Guesthouse, now The Inn at Rancho Santa Fe. Shown here in the 1950s is the main building set into a radial-shaped landscape and encircled by Sinnard's sinuous road system. The generous front parkland also reaches across Linea del Cielo and La Gracia wrapping the front of the entire grounds in a swath of lawn. Under the canopy of eucalyptus are the original cottages introduced in the 1940s during the Richardson ownership and under the direction and management of Reg Clotfelter. Set apart from the main building, these architecturally compatible cottages allowed for seclusion and the privacy of guests, a valued commodity on the ranch.

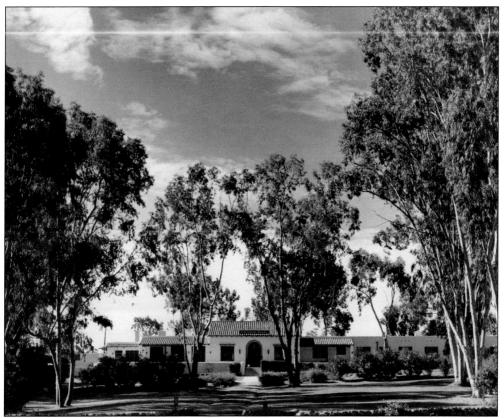

LA MORADA (THE INN AT RANCHO SANTA FE). Seen here in the 1940s, the building shows its signature front arch. The building and the grounds reveal their basic simplicity from their origins without excessive ornamentation. The monoculture of eucalyptus further alludes to the fact that the person is in Rancho Santa Fe.

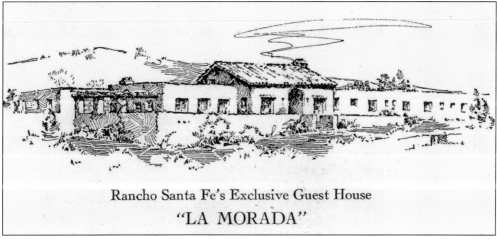

Rancho Santa Fe's Exclusive Guest House
"LA MORADA"

RENDERING OF LA MORADA. This drawing was taken from the original rendering generated by the architectural firm of Requa and Jackson on behalf of the Santa Fe Land Improvement Company, although ghosted by architect Lilian Rice. It was used for hotel-rate brochures and other publications.

THE INN AT RANCHO SANTA FE, MANZANITA AND ACACIA COTTAGE. The original cottages added during the 1940s may have pioneered the concept of the boutique hotel experience. More like small homes rather than hotel rooms down long corridors, they allowed visitors to be temporary ranch residents. Each cottage had a distinctly unique design. The Manzanita Cottage, named for a native chaparral species, had a walled-in patio and was under the canopy of eucalyptus trees. The Acacia Cottage, named for an Australian species but popularized on the ranch, was more of a modern ranch-style cottage fronting a main lawn in the full sun.

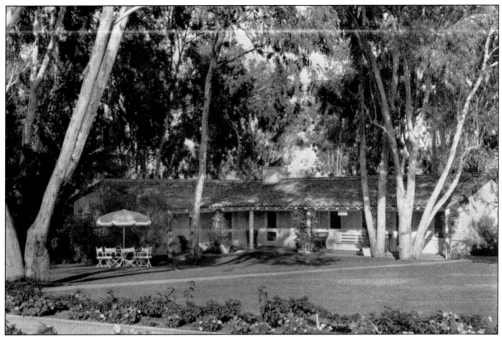

THE INN AT RANCHO SANTA FE, MARIPOSA AND CAMELLIA COTTAGES. The cottages graced the property and brought the visiting experience further out into the landscape. The Mariposa Cottage is reminiscent of a country home. It was set back with a long rambling porch. The Camellia Cottage was the only two-story building meant for families or groups of a larger size. It could almost be mistaken for one of the homes in Rancho Santa Fe. There was and continues to be a great nostalgia for these cottages. Returning guests have come to emotionally own them and request them on a regular basis. They were their homes away from home in Rancho Santa Fe.

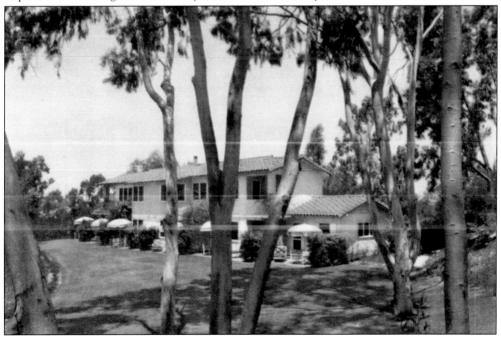

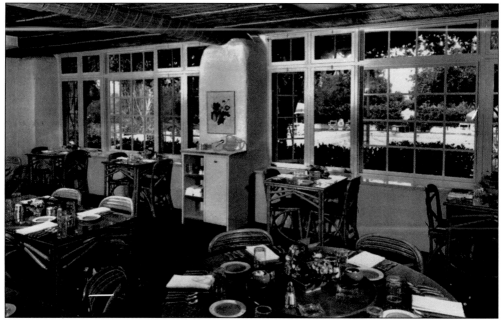

THE INN AT RANCHO SANTA FE, THE BAMBOO ROOM. Dining at The Inn took on many trends over the years. Options for dining went from fully formal to luncheon and outdoor dining. In the post–World War II era, bamboo, tiki, and Pacific Island motifs were very popular in California. The Bamboo Room was a casual yet upscale dining experience.

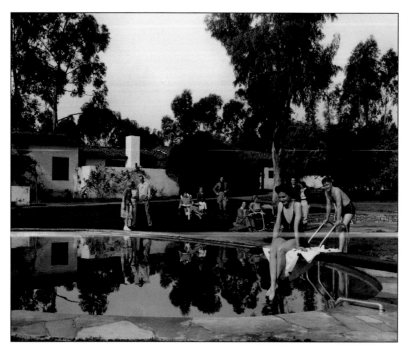

EL RANCHITO GUEST RANCH. In 1928, Everett Smith bought 15 acres filled with eucalyptus and sage near Lago Lindo (Beautiful Lake) to build his "country place," a second home away from Hollywood. Later it became known as El Ranchito, a guest ranch that was delightfully informal, and country casual.

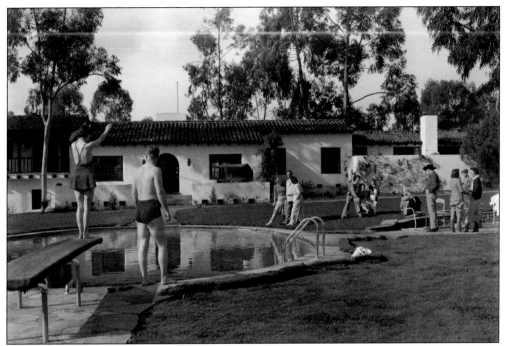

EL RANCHITO GUEST RANCH, 1940s. The guest ranch was known for greeting its guests with genuine California hospitality. Later it became known as the Wishing Well Hotel. Eventually the property was sold and subdivided. Today Los Eucalyptus is the name of the street that leads to the many houses that occupy this beautiful setting.

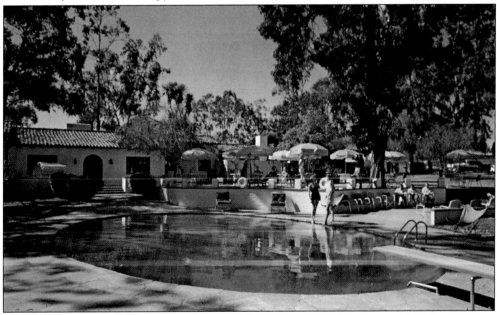

THE WISHING WELL HOTEL. A stay at the secluded Wishing Well Hotel owned by Julia and Larry Larrea was marked by relaxation amidst country elegance. It featured gourmet dining, musical entertainment, and Sunday buffets. Several private casitas were built on the 11-acre property under the eucalyptus, and of course there was a wishing well in the garden.

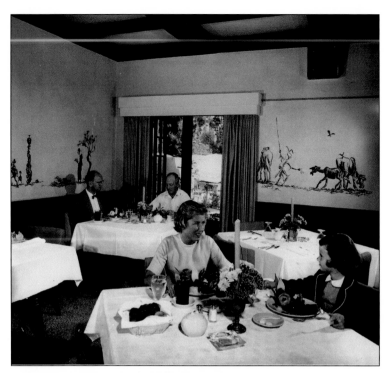

THE WISHING WELL HOTEL DINING ROOM. Enjoying the cuisine in the elegant Don Quixote Room are Patricia Manion and her daughter Holly. The room was painted with scenes from the novel *Don Quixote*. All the wall paintings, wood, and stained-glass detailing in the hotel were designed by artist James Hubbell, whose mother, Julia Larrea, owned the hotel. (Courtesy Manion family collection.)

SECOND HOME TO RANCHO SANTA FE SCHOOL. By 1931, there were 45 families on the ranch. The new school housed 35 to 40 students, grades one through six, who shared two teachers, Mrs. Trethaway and Mrs. Ross. In 1955, a new and final school was built on La Granada between El Fuego and Avaendia de Acacias. Today the building houses the Rancho Santa Fe Association.

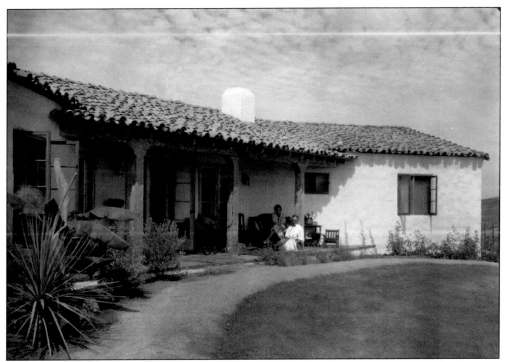

THE BARTON MILLARDS AT HOME. Barton Millard played a significant role in the early development of Rancho Santa Fe. He was in the original group of 60 landowners who first signed on to the Rancho Santa Fe Protective Covenant. He also served as the president of the Rancho Santa Fe Country Club, the Association, and several committees. He was a real estate agent in the beginning, but as his orchards grew he became a full-time orchardist.

THE SAN DIEGUITO RESERVOIR, A SCENIC NEIGHBOR. The wide-open spaces and the central lake-like feature of the San Dieguito Reservoir made the surrounding land ideal for premium lots and estate homes. Uninterrupted views were afforded across the landscape, and to the north a lovely ridge of hills completed the vista.

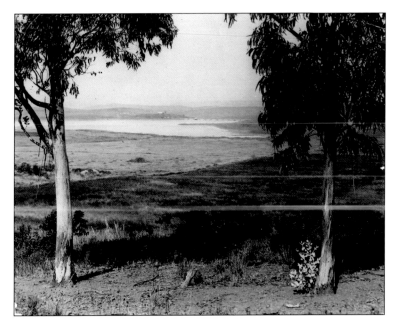

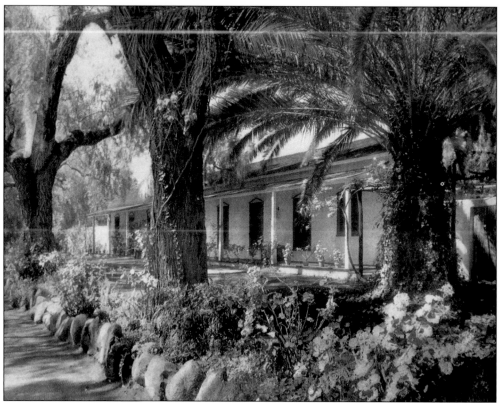

OSUNA 2, THE BING CROSBY YEARS. Bing Crosby and his wife, Dixie, bought the Osuna 2 property in the early 1930s as a getaway from Hollywood. Each year, they spent more time on the ranch because of Bing's involvement in the development of the Del Mar Race Track. Bing restored and expanded the property with the able assistance of architect Lilian Rice. The family sold the property in the mid-1950s.

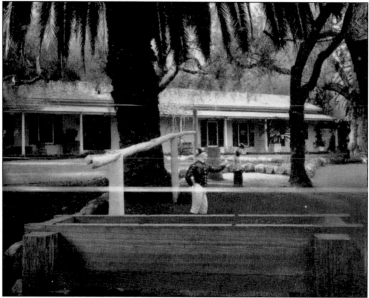

OSUNA 2, A HOMAGE TO HORSE RACING. Bing's garden ornaments reflected his dedication to horse racing. A president of the Del Mar Turf Club, he entertained many like-minded friends and notable celebrities. Also, as an avid golfer his presence at the Rancho Santa Fe Golf Club was critical to its success during the Depression.

BING CROSBY AT A CLAMBAKE. Bing Crosby was an avid golfer and played the Rancho Santa Fe course almost daily. In 1934, Crosby hosted a fun tournament that mixed jockeys, trainers, and owners of horses at the Del Mar Race Track with members of the golf club. In 1937, Crosby put up a $3,000 purse and sponsored the first Bing Crosby Pro-Am tournament. He selected famous professionals and friends from Hollywood to play. Bing called the tournament "the clambake." The first six Bing Crosby Pro-Am tournaments were played at Rancho Santa Fe from 1937 to 1942. These tournaments drew the greatest names in golf and the largest crowd to Rancho Santa Fe ever and offered personal, hometown clambake hospitality.

RANCHO SANTA FE STATE LANDMARK PLAQUE. On February 3, 1989, Rancho Santa Fe was unanimously approved as a California State Historical Landmark, No. 982. The plaque was dedicated on June 2, 1989. Subsequently, in June of 2004 the landmark was amended to include all elements of the cultural landscape: architecture, roads, vegetation, vistas, natural systems, and site planning.

LA FLECHA HOUSE, HOME TO THE HISTORICAL SOCIETY. In a support letter for the California landmark designation, Edwin and Marguerita Reitz granted permission to be included in the process. In their trust they left the La Flecha House and all its contents to the Rancho Santa Fe Historical Society on July 4, 1989.

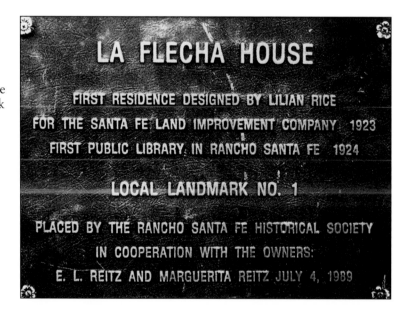

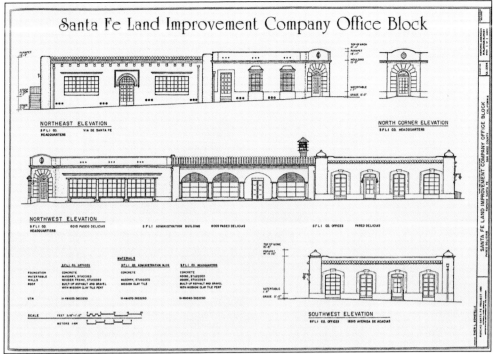

NATIONAL REGISTER DOCUMENTATION. The Rancho Santa Fe Historical Society and the Rancho Santa Fe Association worked together to bring a Historic American Building Survey (HABS) team to the ranch to document the village buildings designed by Lilian J. Rice. HABS was founded in 1933 within the National Park Service to help establish a program for recording historic buildings in the United States. What resulted was the listing of several buildings, designed by Lilian J. Rice, on to the National Register of Historic Places. Shown here are measured drawings of the Santa Fe Land Improvement Company and the village, just a sampling of what was recorded.

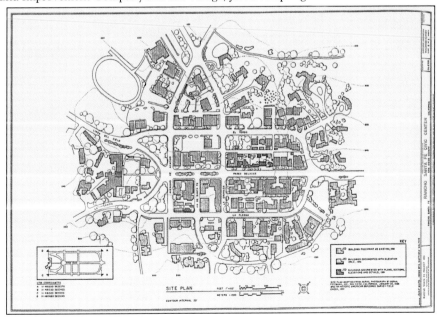

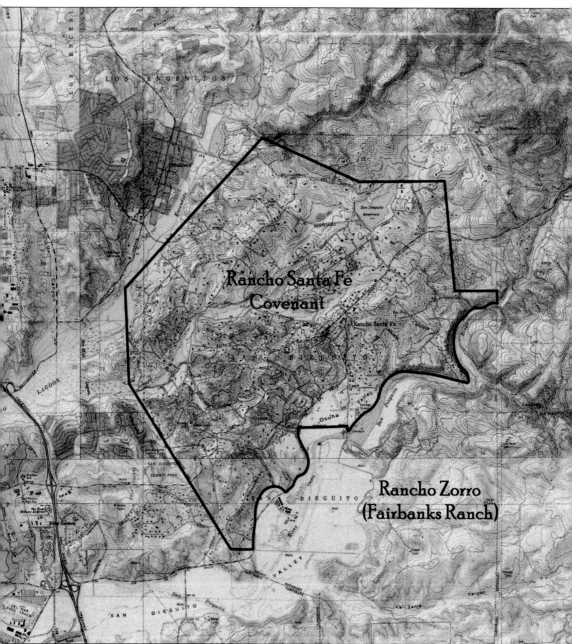

RANCHO SANTA FE PROTECTIVE COVENANT AND RANCHO ZORRO. An early USGS map shows North County San Diego. The dark line added shows the legal boundary of the Rancho Santa Fe Protective Covenant. It is interesting that within the boundary one can see the dramatic topographical character and adjacency to a major waterway, both of which attracted Juan Osuna and later the Santa Fe Railway to the site. The southeastern boundary follows the channel of the San Dieguito River. All land on the opposite side was once Rancho Zorro and fields of Valencia orange groves, now the exclusive community of Fairbanks Ranch. Together both the Rancho Santa Fe Protective Covenant and Fairbanks Ranch make up the old Mexican Republic–era Rancho San Dieguito.

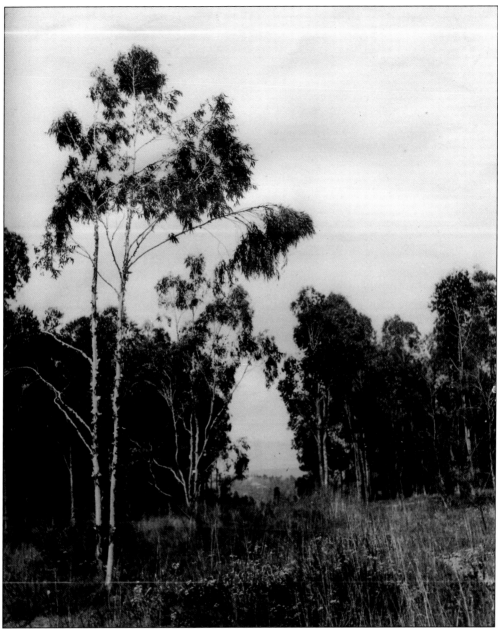

EUCALYPTUS: THE MUSE OF RANCHO SANTA FE. When one thinks of the physical setting of Rancho Santa Fe, eucalyptus trees always come to mind. During the administration of Theodore Roosevelt, the president attempted to resolve a projected hardwood famine that would especially affect California. A government bulletin went out that promoted mass planting of eucalyptus in all parts of the Southwest where they would naturally adapt. What the railroads didn't know is that Australia used the trees as railroad ties, but only those that were centuries old. The Santa Fe learned the hard way, after investing time and resources, that the government hadn't tested their recommendations. What is left from the Santa Fe's epic experience, providentially, is a forested reminder that if it hadn't been for the eucalyptus, Rancho Santa Fe would never have come to pass.

DISCOVER THOUSANDS OF LOCAL HISTORY BOOKS
FEATURING MILLIONS OF VINTAGE IMAGES

Arcadia Publishing, the leading local history publisher in the United States, is committed to making history accessible and meaningful through publishing books that celebrate and preserve the heritage of America's people and places.

Find more books like this at
www.arcadiapublishing.com

Search for your hometown history, your old stomping grounds, and even your favorite sports team.

Consistent with our mission to preserve history on a local level, this book was printed in South Carolina on American-made paper and manufactured entirely in the United States. Products carrying the accredited Forest Stewardship Council (FSC) label are printed on 100 percent FSC-certified paper.

MADE IN THE USA